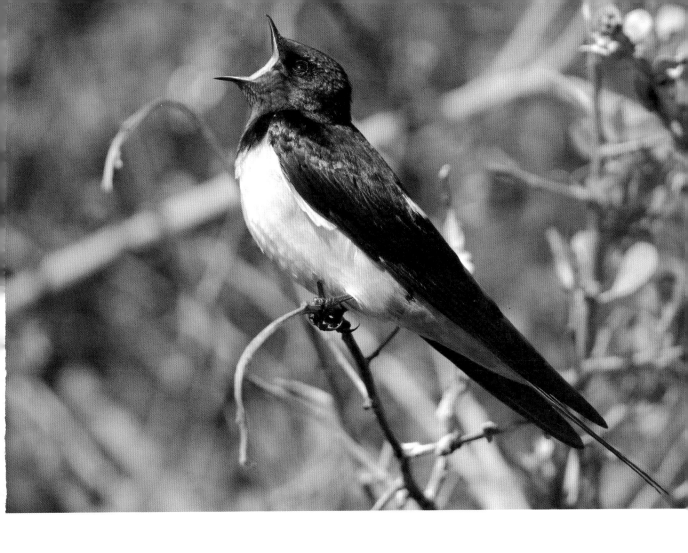

WORLD'S BEST BIRD SONGS

DEDICATION

This book is dedicated to late Ilkka 'Emu' Lehtinen
– dear friend and great admirer of music created by
birds and humans alike.

First published in 2018 by Reed New Holland Publishers Pty Ltd
London • Sydney • Auckland

131–151 Great Titchfield Street, London WIW 5BB, UK
1/66 Gibbes Street, Chatswood, NSW 2067, Australia
5/39 Woodside Avenue, Northcote, Auckland 0627, New Zealand

newhollandpublishers.com

A record of this book is held at the British Library and the
National Library of Australia.

ISBN 978 1 92151 787 7

Group Managing Director: Fiona Schultz
Publisher and Project Editor: Simon Papps
Designer: Andrew Davies
Production Director: James Mills-Hicks
Printer: Toppan Leefung Printing Limited

10 9 8 7 6 5 4 3 2 1

Keep up with New Holland Publishers on Facebook
facebook.com/NewHollandPublishers

WORLD'S BEST BIRD SONGS

Hannu Jännes

INCLUDES APP WITH
SONGS AND CALLS OF
70 ICONIC SPECIES

CONTENTS

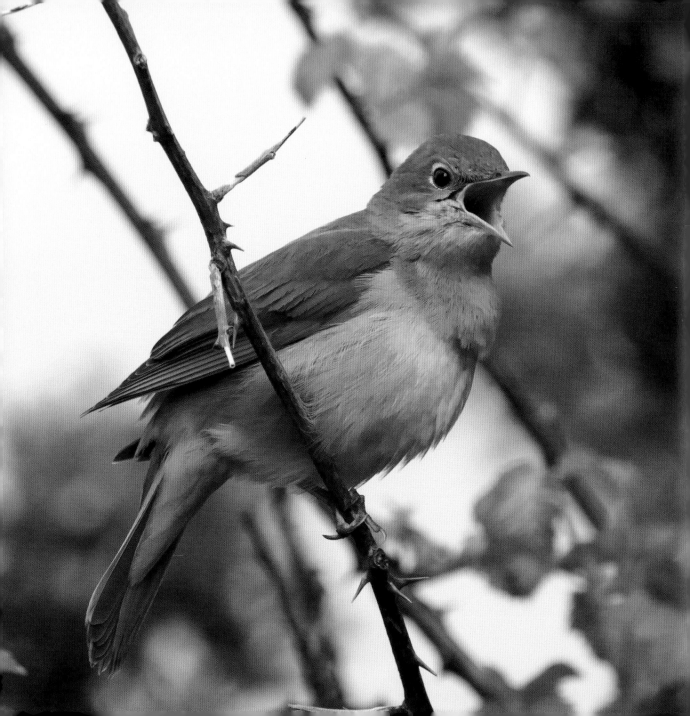

INTRODUCTION

Birds can be found practically everywhere, from steamy jungles to treeless cold tundra and from inhospitable deserts to high mountain tops. They even live in close proximity to human beings and a number of bird species are adaptable enough to survive among us even in the biggest cities. Although we may not always see them, we will definitely hear them all around us if we pay attention.

Birds have the greatest sound-producing ability of all vertebrates, and they certainly use their skills to communicate among themselves mostly by singing and calling. Vocal communication is a very efficient way to spread your message across long distances and in habitats such as dense forest, where visual signals just don't work. For us humans a bird song or call may sound beautiful or even funny, but for a bird it is an important method of conveying information such 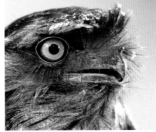 as territorial ownership, sexual intention, status, body condition, location, and so on, and every bird species has its own diagnostic language.

In addition to vocal utterances, birds also make noises with their bills (on the App listen to the sound of bill-clapping, which is part of the ceremonial display of the Southern Royal Albatrosses, and the drumming of the Black Woodpecker), wing-beats (fighting Black Grouse) or tail-feathers (display flight of the Common Snipe), while some even use their feet.

In this book I have attempted to make a selection of bird species in order to portray examples of the variety of songs, calls and other means of communication used. Admittedly 70 species is a very small proportion of the more than 10,000 bird species living on our planet, but hopefully it gives the reader an idea of the great variety of bird vocalisations. In addition to the obvious choices of a number of the most accomplished and beautiful singers, such as the two species of nightingale, Common Blackbird, White-rumped Shama and Wood Thrush, which are all admired by a great many people, I wanted to present a selection of bird sounds that are common in their respective areas of distribution and form an integral part of the local soundscape, such as Common Cuckoo, Common Chaffinch, European Robin and Willow Warbler in Europe, Asian Koel, Coppersmith Barbet and Oriental Magpie-Robin in Asia, Crested Bellbird and Chiming Wedgebill in Australia, Hadada Ibis in southern Africa, and so on. Many of the birds chosen are well known by local people and have even found their way into folklore and religion.

In addition I have selected a number of examples of exceptional vocal performances, including the songs of the Superb Lyrebird and the Marsh Warbler, which are both master imitators, and the amazing song of the Yellow-bellied Bush-Warbler. As examples of weird songs (for us humans that is – for the birds they are just part of their normal communication) the vocalisations of Horned Screamer, Capuchinbird, Cory's Shearwater, Eurasian Bittern and Black-bellied Bustard are included. And then there is of course a selection of iconic birds such as African Fish-Eagle, a species of kiwi, Great Hornbill, Southern Royal Albatross and Common Crane, and obviously no bird sound collection would be complete without representation from the nightbirds with their wonderful and mysterious calls.

HOW TO USE THIS GUIDE

Step 1
Go to the App Store
or Google Play and
download World's Best
Bird Songs App.

Step 2
Open App.

Step 3
Scan the square QR code
on the page ...

... and hear the bird song.

For more information go to newhollandpublishers.com/birdsongs.

ACKNOWLEDGEMENTS

In addition to all the photographers and sound recordists who have helped to create this work (see the list of contributors at the end of the book), a number of people have kindly helped me with suggestions of species that should be included in this collection. I would especially like to thank Pete Morris, János Oláh, Nik Borrow, Keith Barnes, David Stewart, Peter Boesman, Tuomas Seimola, Marc Anderson, James Wolstencroft, Mark van Beirs and Jeremy Hegge for their contributions. Special thanks to Simon Papps, my publisher at Reed New Holland, a person with great patience and skill who kept this project alive even when I had my doubts.

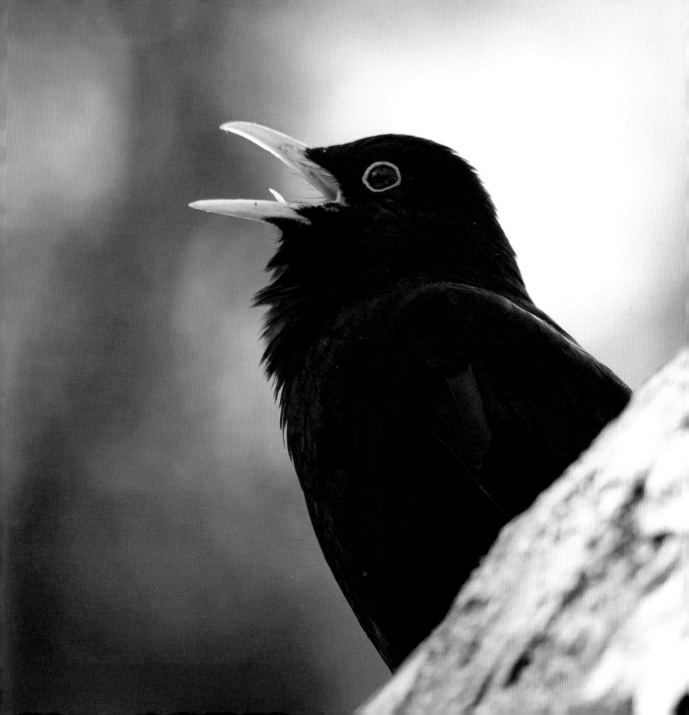

01 | **North Island Brown Kiwi**
Apteryx mantelli

Kiwis, which occur only in New Zealand, are very unusual-looking birds with a large, cone-shaped body, a small head and a long bill which they use to dig up food from the ground. They are flightless and mostly nocturnal in their habits. Of the five kiwi species currently recognised the North Island Brown Kiwi is one of the more common, with a population of about 35,000 individuals living in the forests of North Island and formerly also northern parts of South Island.

All kiwi populations have dwindled dramatically in numbers during the last hundred years due to the destruction of native woodland. In addition kiwis, and especially their eggs and chicks, are suffering from predation by imported animals such as stoats, and special protection measures are required to save them from extinction.

■ Kiwis communicate with very loud, shrill calls. When heard suddenly in the middle of a deep forest in the darkness of the night this can be a really heart-stopping experience.

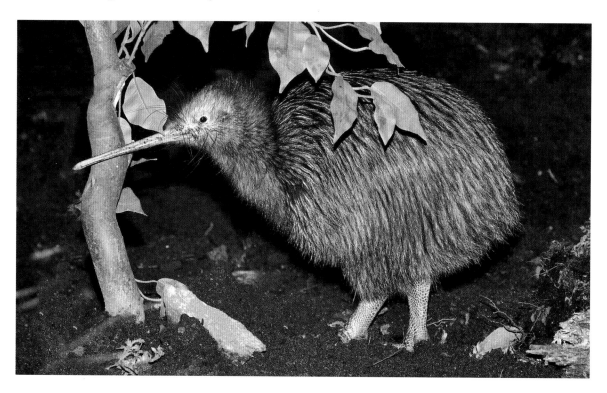

02 | **Horned Screamer**
Anhima cornuta

This large bird, which has long legs, a stocky body and a small chicken-like head and bill, looks rather like an odd gamebird but actually belongs to the same order of waterbirds as ducks, geese and swans. The Horned Screamer lives in the open savanna, meadows, marshes and lakes of tropical South America, where its calls form an important part of the soundscape.

Thanks to their noisy habits, screamers are sometimes considered a nuisance by people, especially hunters, as the alarm call of one bird immediately warns all other animals of human presence. For the same reason domesticated screamers are used as 'watchdogs' because they are always alert and give warning sounds at the slightest suspicious movement.

■ An extremely vocal species that is able to utter its phenomenally loud call, which can carry up to 3km (2 miles), for hours on end. Once one bird begins vocalising it is often joined by other screamers living within earshot.

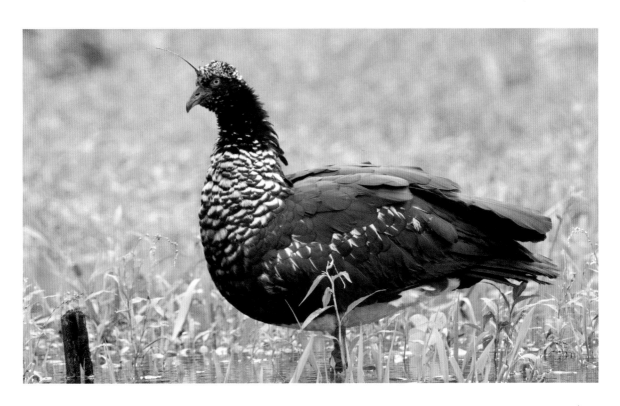

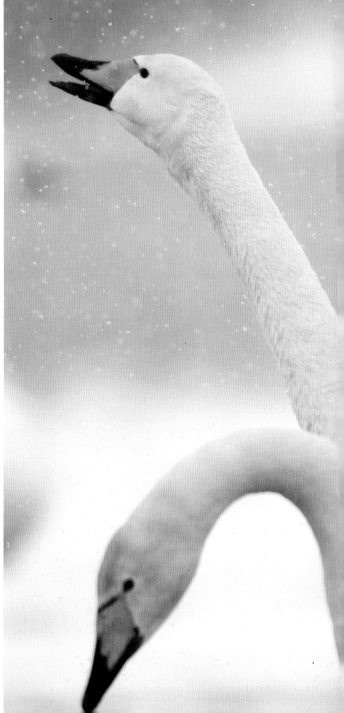

03 | **Whooper Swan**
Cygnus cygnus

Breeds mainly in the forest zone of northern Eurasia and migrates further south for the winter.

The history of the Whooper Swan in Finland is an excellent example of how dedicated nature conservation can work miracles in relatively short period of time. In the 1950s there were only about 20 pairs breeding in the whole of Finland, mostly in remote parts of the north of the country, but thanks to people's awareness of the species' plight and the urgent action taken, the swans were fully protected from hunting and started to recover and extend their range southwards. Today the Whooper Swan breeds in the whole of the country with an estimated population of 6,000 pairs, and it has also been chosen as the national bird of Finland.

■ The wild whooping calls of a large flock of these swans at a migration stop-over site.

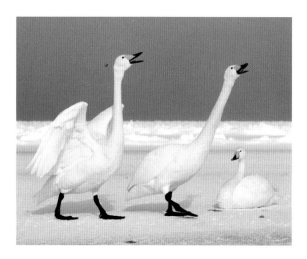

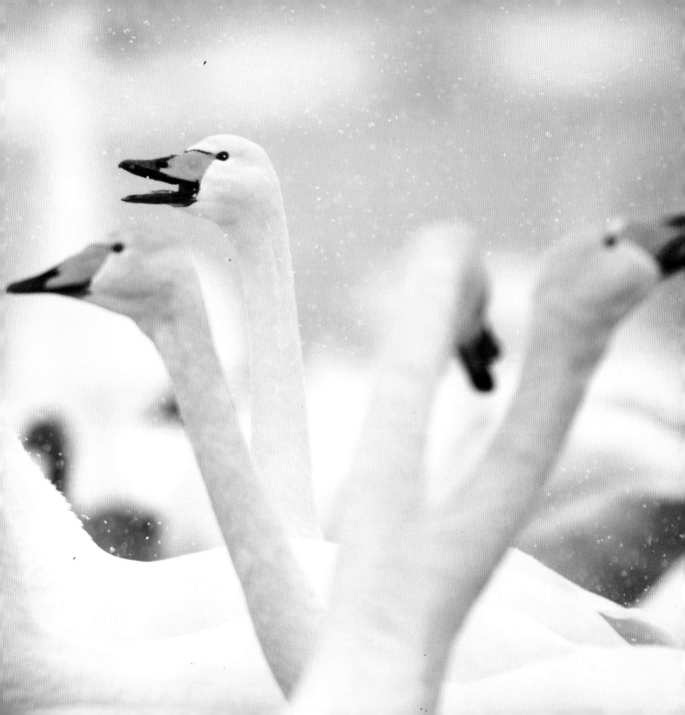

04 | **Black Grouse**
Lyrurus tetrix

In order to attract and court females male Black Grouse congregate on communal display grounds known as leks, where they prove their fitness against other males by showing off their gorgeous glossy black plumage with some white feather tracts, their long lyre-shaped tail, and the bright red comb above the eye. They move theatrically around with drooping wings and head, occasionally jumping up in the air and, when necessary, picking a fight with the most irritating neighbouring male. During all this hustle and bustle the male keeps singing its song which starts with a bubbling trill.

The display and singing starts in early spring and continues for a month or two, and is one of the magical sounds of the spring in northern Europe. The species' range also extends into parts of central and even southern Europe, and right across Asia to eastern parts of Russia and China.

■ The male Black Grouse singing its far-carrying bubbling trill, followed by cooing, and at times interrupted with a loud hissing sound.

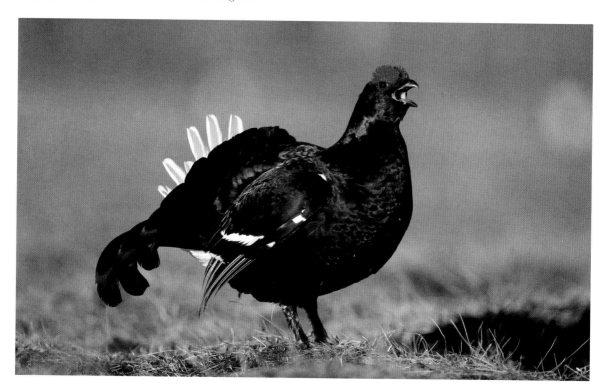

Tibetan Snowcock
Tetraogallus tibetanus

If you ever hear the whistling and chuckling sounds of Tibetan Snowcock in the wild you are probably surrounded by amazing scenery and gasping desperately for more oxygen in the thin mountain air, as this plump gamebird is a denizen of the high mountains of the western Himalayas and the Tibetan Plateau.

In summer it occurs as high as altitudes of 5,800m (19,000ft) above sea-level, moving down to 2,500–4,000m (8,000–13,000ft) in winter. It favours alpine pastures and rocky ridges with very little vegetation, but still manages to eke out its meagre living in this harsh environment.

■ The far-carrying curlew-like whistles and chuckling calls of two interacting Tibetan Snowcock males, which were recorded at Bayankala Shan Pass in Sichuan, China, at an altitude of 4,500m (14,750ft) above sea-level.

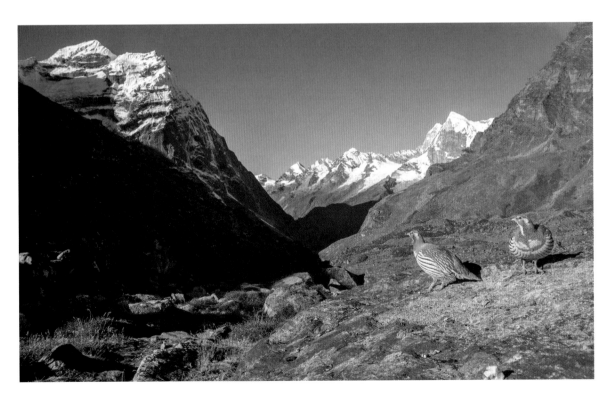

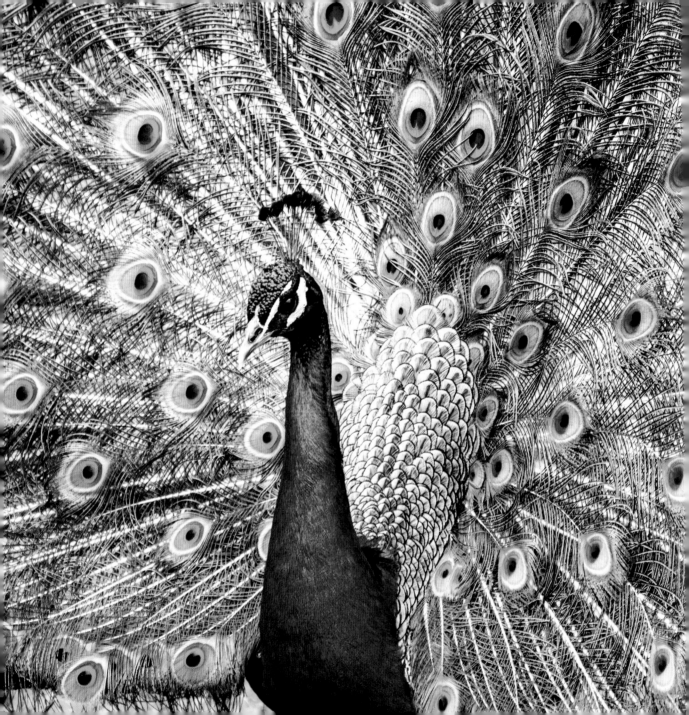

Indian Peafowl
Pavo cristatus

This large pheasant is endemic to the Indian Subcontinent where it is widespread and common in areas where it is protected. It lives in rather dry, open forests and also around areas of cultivation and human habitation, and can be surprisingly tame for a bird of its size.

The Indian Peafowl is the national bird of India. Thanks to introduced feral populations that exist in many corners of the world this impressive species has become familiar well outside its natural range, but it is still something special to actually experience them in the wild in their natural habitat. The male is among the most elaborately plumaged of all birds on Earth and the call is pretty amazing too.

■ An early morning chorus of Indian Peafowl roosting in tall trees on the outskirts of a small village in Rajasthan, India.

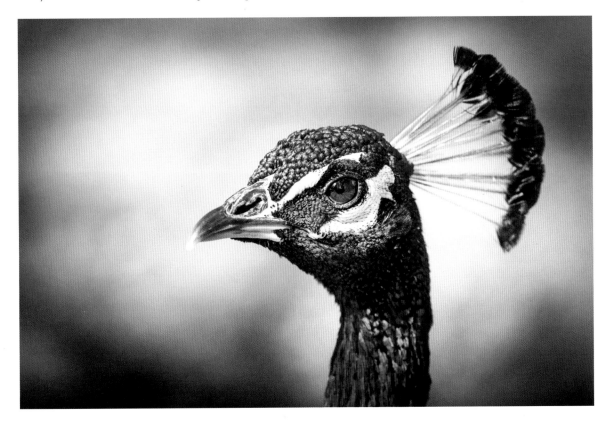

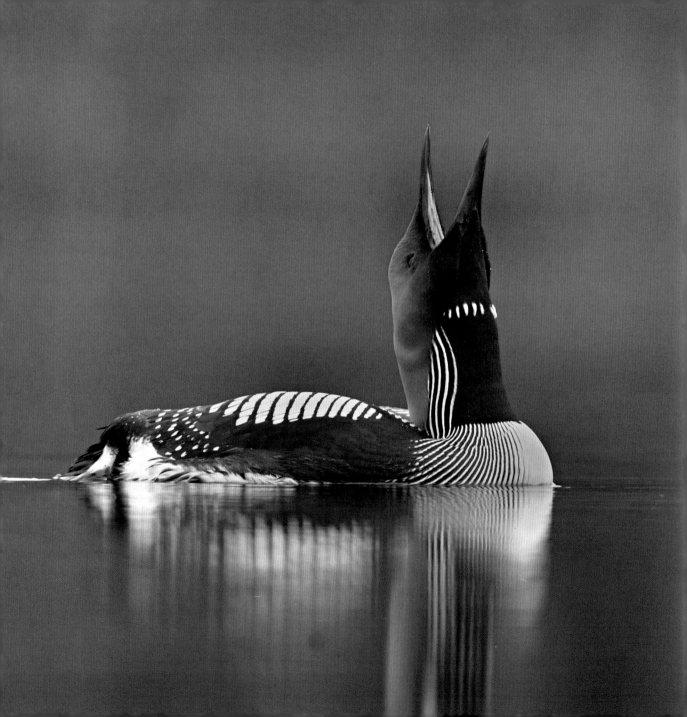

07 | **Black-throated Diver**
Gavia arctica

This species, which is also known as the Arctic Loon, is a characteristic breeding bird of oligotrophic, nutrient-poor lakes across northern Eurasia. There are many such lakes in the taiga belt in Scandinavia, where nearly every suitable stretch of water hosts at least one pair of this handsome bird.

In addition to their good looks the birds also draw attention with their remarkably wild and far-carrying vocalisations. They are highly vocal at the beginning of the breeding season, but later in the summer most of the vocal activity takes place during the night when breeding pairs communicate with birds occupying other parts of the lake.

The wailing cries are well known and much loved by local people and visitors alike. The species' Finnish name 'kuikka' is an onomatopoeic name originating from the birds' song.

■ The rhythmic whistling song of the male is a typical sound of midsummer nights in northern Eurasia. Other calls heard here are the wailing greeting and growling warning calls.

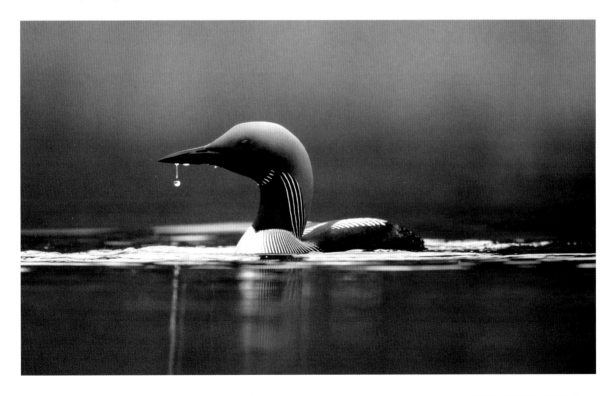

08 | King Penguin
Aptenodytes patagonicus

The tall and handsome King Penguin breeds in large or even huge (up to 100,000 birds) colonies on Subantarctic islands. A big colony is an extremely crowded and noisy environment, especially during the time when the adults are displaying, and when birds returning from fishing trips attempt to find their mate or locate their hungry chick.

The young spend their time in large communal crèches. From among groups of tens of thousands of birds the adult and young can locate each other by using extremely small vocal cues – a sort of a vocal fingerprint and a small miracle considering the number of birds and the amount of noise in the colony. To us humans they all sound similar.

■ In this recording from the outskirts of a huge colony on South Georgia you can hear the hustle and bustle of a busy and crowded colony, including the trumpeting calls of the adults, a series of whistled calls of young birds, and the footsteps of birds pottering around in the soft mud.

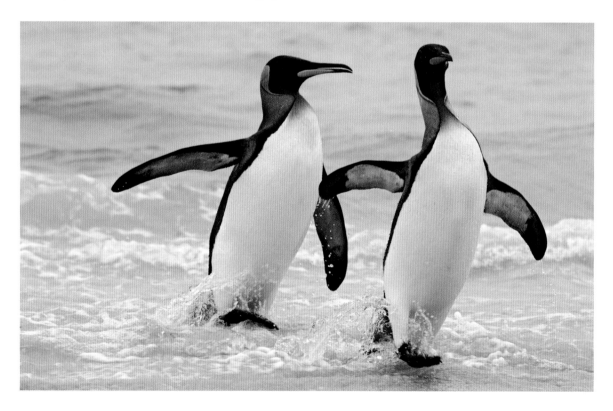

09 | **Southern Royal Albatross**
Diomedea epomophora

One of the largest albatross species, with a wingspan of around 3m (10ft) and weighing about 9kg (20lb). It breeds on remote islands around New Zealand and, most unusually for an albatross, also on the mainland of South Island at Dunedin. Young birds disperse widely over the vast Southern Ocean only to return to their home island at the age of 3–4 years, when they start to look for a mate for life. Breeds for the first time at the age of 6–12 years.

■ On this recording, which was made on the grassy slopes of the remote Campbell Island, a young, non-breeding pair of albatrosses is performing pair-bonding courtship rituals to each other, and react strongly towards a lone intruder every time it glides past them – you can actually hear the 'whoosing' sound from the wings of the intruder.

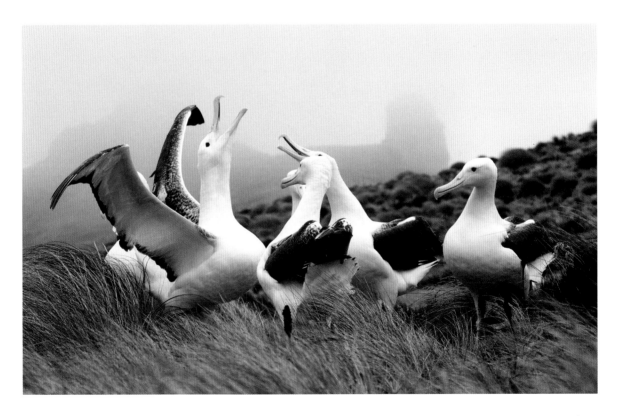

| **Cory's Shearwater**
Calonectris borealis

Cory's Shearwater breeds mainly on barren islands in the East Atlantic, including the Azores, Madeira, the Canary Islands and off the coast of Morocco. The birds winter in the waters of the South Atlantic. The single egg is laid in a self-dug burrow, rock crevice or other type of natural hollow. Flocks of Cory's Shearwaters swimming lazily close to the shore and being mute, or nearly so, might not be the most obvious choice for inclusion in a collection of the world's best bird songs, but the scene changes dramatically when night falls and the birds start to return to their nesting colonies to feed their single chick or release the other parent from its incubation duties.

■ Arriving birds are communicating eagerly with their waiting partners and hungrily begging offspring with highly unusual nasal sounds, which in the darkness of the night creates a very special experience.

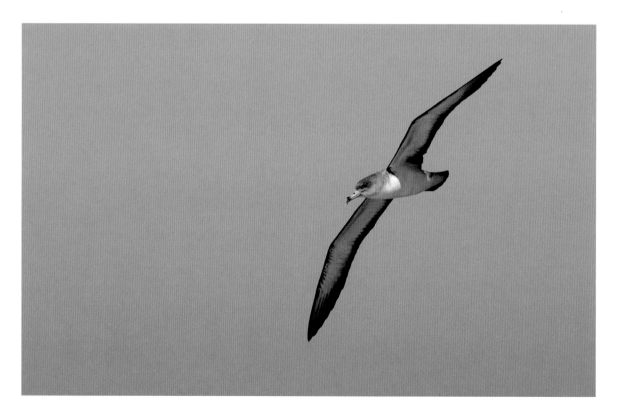

11 | **Hadada Ibis**
Bostrychia hagedash

With its dirty brown-grey body plumage, metallic purple or green sheen on the wing, some red on the longish decurved bill, and a whitish moustachial stripe, the Hadada Ibis is definitely not the most attractive-looking species of bird. However, thanks to its very wide distribution in Sub-Saharan Africa and an ability to adapt to many types of open environments, including artificial habitats such as residential suburbs, parks, large gardens and golf courses, and its amazingly loud calls, it is a very well-known bird throughout its range.

■ The Hadada's raucous, nasal calls, an inseparable element of the African soundscape, are best heard at dawn and dusk when the perched birds give, often in duet, a drawn-out single note *waaah* and flying birds utter a multisyllabic *ha-ha-de-dah* call. The latter call is also the origin of the species' onomatopoeic name 'Hadada'. On this sample you will hear both the calls described above.

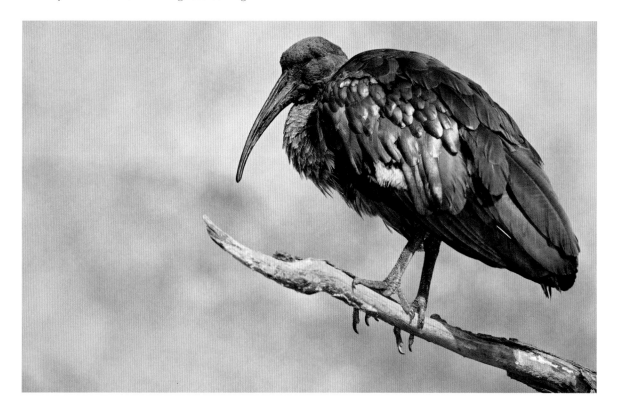

12 | **Rufescent Tiger-Heron**
Tigrisoma lineatum

A rather large and handsome heron which in adult plumage has rufous on the head and neck, a black mantle, grey wings and a strong, dagger-shaped bill that is perfectly suited for catching all kinds of aquatic creatures, including fish, insects, amphibians, crustaceans, snakes and even small alligators.

The species is very widespread in the northern half of South America, living solitarily or in pairs along forested banks of slow-flowing rivers and in swamps. It is mainly nocturnal in its habits and has been observed using bait to catch small fish – a behavioural trait that it shares with some other species of herons.

■ The powerful, rhythmic groaning is one of the most mysterious animal sounds of the wetland margins of South America. The call of the Rufescent Tiger-Heron causes your imagination wander in the dark forest, making the hairs on the back of your neck stand on end and perhaps causing you to look over your shoulder more often than normal.

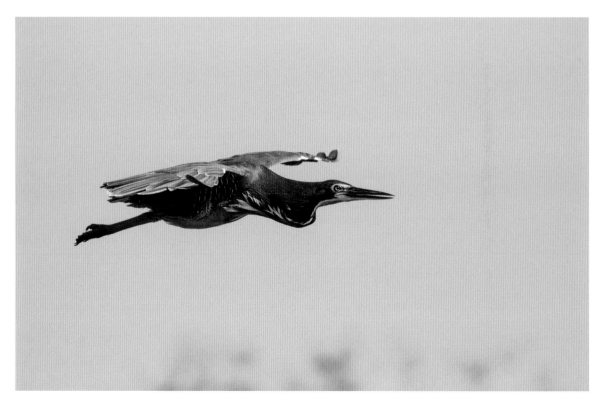

13 | **Eurasian Bittern**
Botaurus stellaris

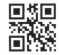

The Eurasian Bittern and the three other species of *Botaurus* bitterns found in the world are members of the heron family, but they have shorter necks and legs and a stouter body than many of their relatives, and lack the exaggerated ornamental plumes so characteristic of many other herons. Additionally most herons are highly visible birds, but the Eurasian Bittern prefers to stay unseen, hiding inside dense reedbeds and in other aquatic vegetation, where its cryptic plumage of browns, buffs, blacks and yellows blends in masterfully and makes it almost invisible.

The male utters a mighty 'booming' song in order to attract the attention of potential mates. The species is widespread through Eurasia, and also occurs in South Africa. The time to hear its awesome 'song' is during the breeding season.

■ The mighty advertising song, which comprises short, pumping notes followed by 2–4 deep booming sounds. In ideal conditions the sound of this 'booming' song can carry for several kilometres. In the recording the bittern's vocalisations are accompanied by a number of other avian reedbed inhabitants such as warblers.

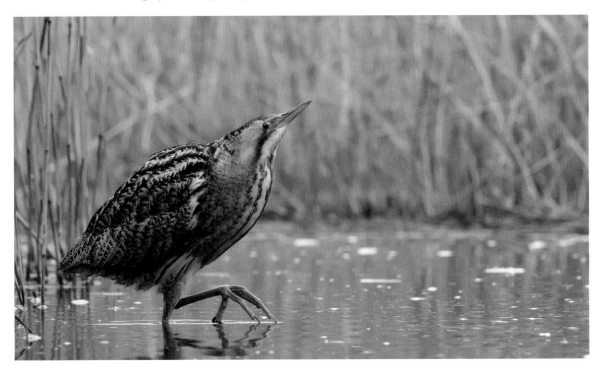

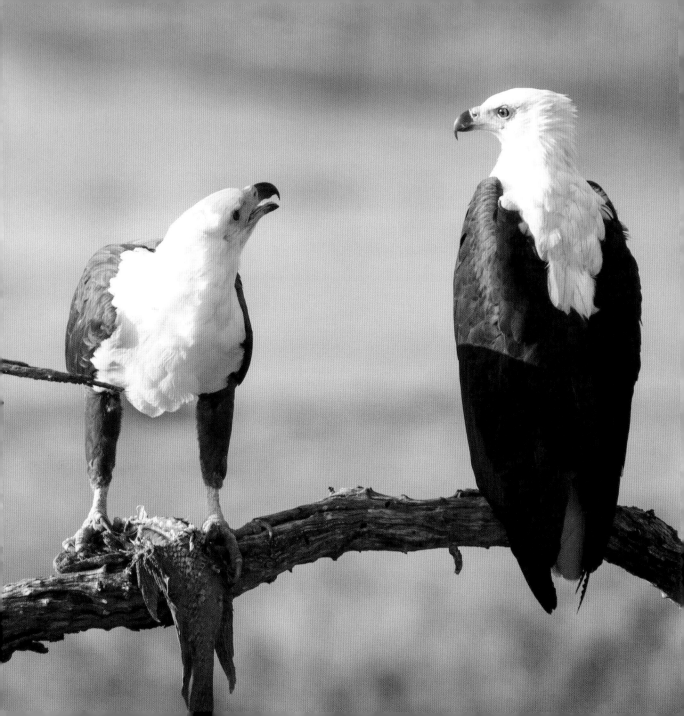

African Fish-Eagle
Haliaeetus vocifer

The eight species of sea-eagles or fish-eagles in the genus *Haliaeetus* include such mighty birds as the Bald Eagle, the national bird of USA, the massive Steller's Sea Eagle of north-east Siberia, and the White-tailed Eagle of Eurasia. The African Fish-Eagle is another very impressive species and it is the national bird of Zimbabwe, Zambia and South Sudan. It is a common and very well-known raptor found throughout the whole of Sub-Saharan Africa, where it occupies many types of large open waterways with abundant supplies of fish, including fresh, alkaline and salt water habitats up to 4,000m (13,000ft) above sea-level.

■ Thanks to its wide distribution and abundance, its loud yelping call, uttered while perched or in flight, is a very familiar waterside sound in Africa, and a part of the African soundscape which is equally as familiar as the call of the Hadada Ibis (see No. 11).

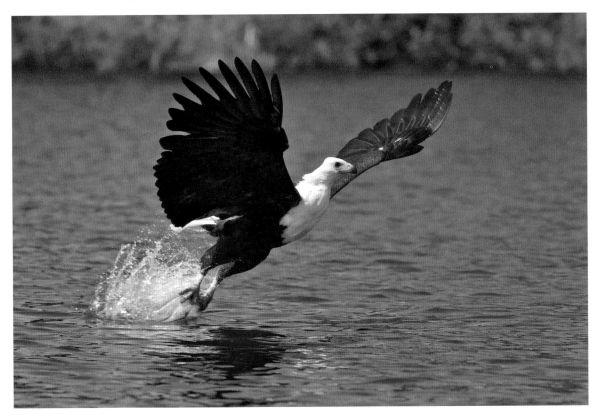

| **Black-bellied Bustard**
Lissotis melanogaster

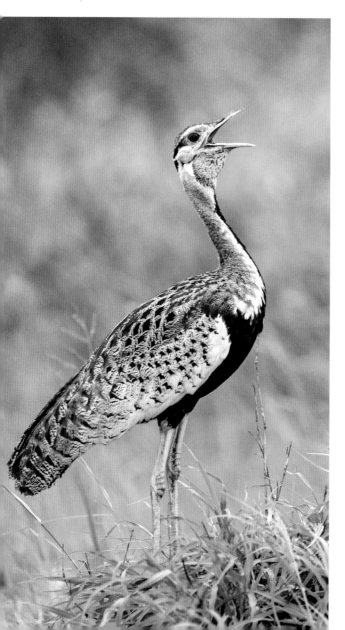

A ground-dwelling species that inhabits tall grasslands and open woodlands. It is widely distributed in Sub-Saharan Africa and the commonest species of bustard in several African countries. The male in particular, with its black and white underparts and brownish back with fine black markings, is a handsome-looking bird.

Despite the birds' large size – they measure about 60cm (24in) in length – and the contrasting plumage of the males, they blend remarkably well into the tall grass in their open habitat and tend to go largely unnoticed by humans. That is until the male climbs onto a termite mound or other elevated spot where it can be seen and heard, and performs its display by retracting its head to its back and giving a short whistle, and after a very short pause, raising its head up again simultaneously uttering a popping sound.

■ The display song of the male Black-bellied Bustard. This quite amusing sound clearly stands out from the noisy chorus of cisticolas, larks and other birds that occupy the same habitat.

Common Crane
Grus grus

Of all the world's 15 species of crane, the Common Crane is the most widely distributed. Its main breeding grounds lie in the northern parts of Eurasia, where it lives on shallow wetlands. It is a long-distance migrant, gathering in winter in huge flocks in areas which can provide plenty of food and safe roosting places. Important wintering areas are located in North Africa, southern Europe, the Middle East, India and China.

The Common Crane, with its mainly grey plumage, attractively decorated head and long neck and legs, is a very eye-catching species. Standing up to 120cm (47in) tall, this is a big bird, and it has a call to match.

■ A breeding pair of Common Cranes delivering their far-carrying, trumpeting duet at dawn, and then flocks of wintering birds flying from their roosting site to surrounding feeding areas.

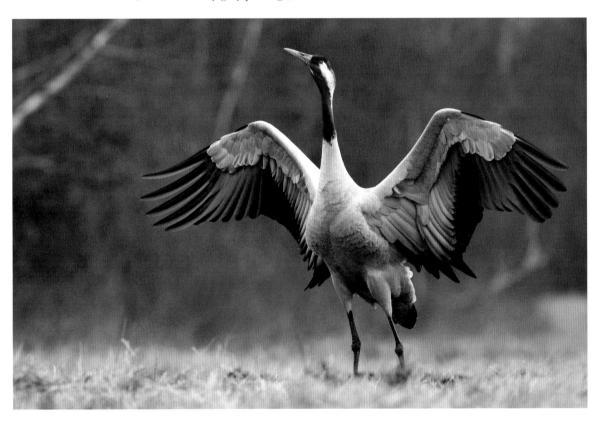

17 | **European Golden Plover**
Pluvialis apricaria

A beautiful bird which breeds in northern parts of Europe and across northernmost Russia all the way to central Siberia. It nests in open habitat on tundra, upland moors, peat bogs, mountains above the treeline, and upland pastures.

In a European birdsong contest organised by BirdLife International the European Golden Plover – the Icelandic candidate – was voted as having the most beautiful birdsong on the continent, and the species clearly deserves its place in this book.

■ You will first hear the plaintive, mellow, sad whistled call, which is also used as an alarm call and greets anyone who dares to approach the territory of a breeding pair. The song, a disyllabic rhythmic whistle, is presented in flight with deep, deliberate wing-beats in slow motion, where the male presents its pure white underwings against the black belly and breast, and is one of the most evocative sounds of its desolate breeding grounds. Another display call is the cyclical almost bubbling series, which is presented at the end of the recording.

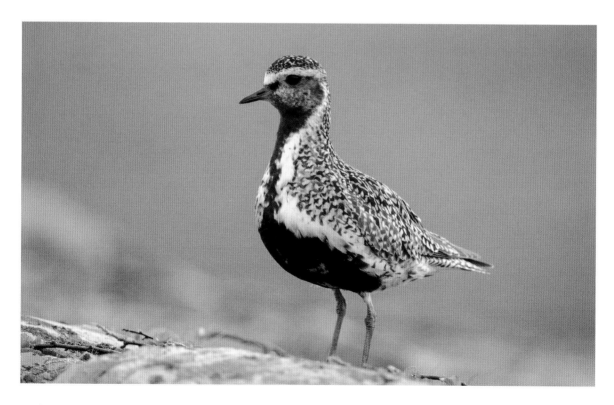

18 | **Common Snipe**
Gallinago gallinago

Birds communicate predominantly by using their voices – songs and calls – and visual cues, but there are exceptions to this rule. The male Common Snipe creates its peculiar non-vocal drumming advertising call in a wide circling display-flight by diving down with outer tail feathers spread out in order to create turbulence. In the process the feathers start to vibrate and create the magical bleating sound during the dive. The male snipe repeats this action countless times, mostly at dusk, over its chosen territory of a wet meadow, bog or marsh during the breeding season, which makes it quite easy to connect with this amazing sound throughout the snipe's breeding range, which extends across northern and central Eurasia.

■ You will hear the 'drumming' display of the male, which is created by air rushing through the bird's tail feathers. The other sound heard here is the species' vocal song, which is delivered from a song post or, as here, in flight. Other examples of non-vocal avian sounds in this collection are the wing noise of the Great Hornbill (No. 30) and the drumming of the Black Woodpecker (No. 32).

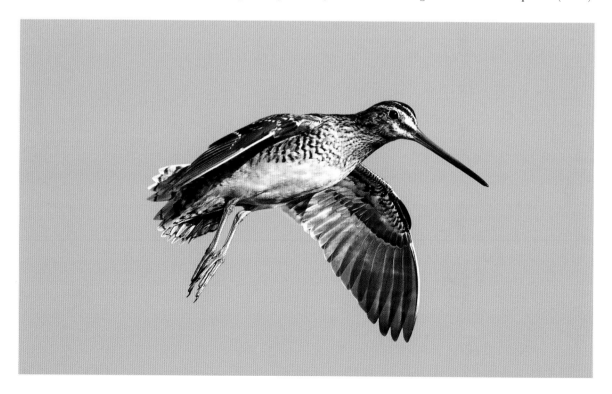

19 | **Black-legged Kittiwake**
Rissa tridactyla

This species is strongly associated with marine habitats and therefore it lives up to the name 'seagull' much more than many of its relatives. During the breeding season the Black-legged Kittiwake is highly gregarious, living on the seaboards of the North Atlantic and North Pacific. It breeds in large, dense colonies of up to tens of thousands of pairs, on steep sea cliffs on the mainland or on offshore islands, where breeding ledges are shared with other birds such as auks and shags. Small numbers of kittiwakes choose buildings as their breeding sites.

Outside the breeding season the birds are highly pelagic and they seek their food, which comprises mainly small fish, out at sea and gather in big flocks in suitable feeding areas or around fishing vessels.

■ Kittiwake is an onomatopoeic name derived from the species' quickly repeated, nasal *kitt-i-waik* call, which, when uttered simultaneously by large numbers of birds at their breeding colony, forms an intoxicating cacophony of noise. This recording was made on Hornøya Island in northern Norway, which is home to 7,500 pairs of kittiwakes.

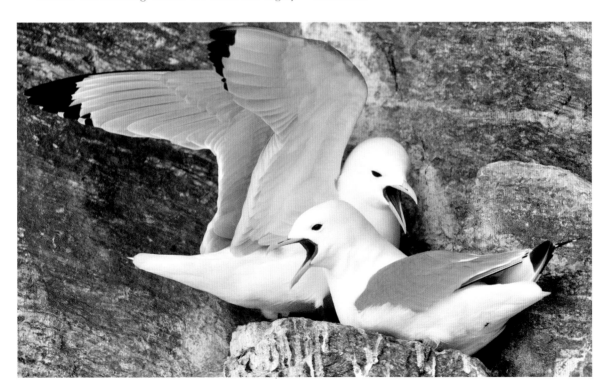

European Herring Gull
Larus argentatus

This large and showy gull is widely distributed in many corners of western and northern Europe, and it is well known due to its survival skills in urban habitats such as fishing harbours, rubbish dumps, parks, lakes and sea shores. Outside the breeding season big flocks can be seen at favourable feeding areas and roosting sites. It is often considered imprudent, ugly and even dangerous due to its boldness and fearless habits, but in fact it is a handsome bird with great looks.

It is resident in places such as the United Kingdom, while in northern parts of its breeding range it is one of the earliest arriving spring migrants. Several forms of large, closely related grey-backed gulls occur across the Northern Hemisphere, and they all have a rather similar repertoire of wild songs and calls.

■ The amazing wild cackling song and evocative calls, which in the north are one of the first signs of the approaching spring.

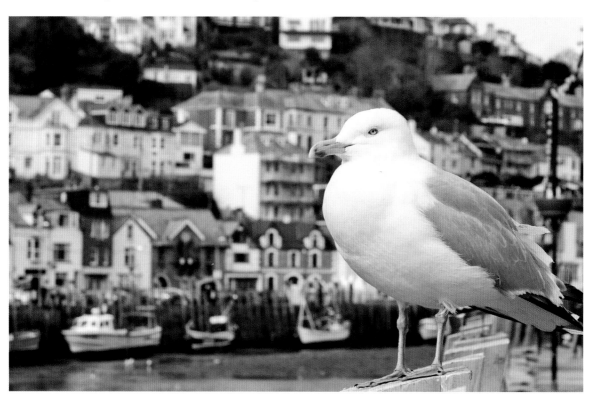

21 | Chestnut-bellied Sandgrouse
Pterocles exustus

One of the world's more widely distributed species of sandgrouse with a range extending from the Middle East to Africa and India, where they exist in many arid habitats including steppes, semideserts and even deserts. These birds are well adapted to life in very dry, harsh conditions, often flying long distances to certain water sources to drink and also to trap some water in their belly feathers in order to carry it back to their offspring.

The sounds of fast-flying water-bound flocks of Chestnut-bellied Sandgrouse are a distinct part of the early morning soundscape in many arid areas where in other respects birdlife can be very scarce.

■ Here are the first calls of a flock of Chestnut-bellied Sandgrouse on their way to water, and then calls of a small nervous flock visiting a small drinking pool together with some White-eared Bulbuls (*Pycnonotus leucotis*), House Sparrows (*Passer domesticus*) and Indian Silverbills (*Euodice malabarica*).

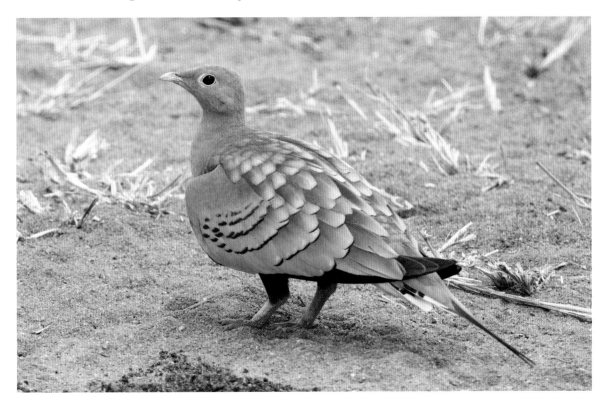

22 | **European Turtle-Dove**
Streptopelia turtur

This handsome, attractively patterned dove breeds in a large area that extends from Western Europe to Central Asia, and its wintering range covers as a rather narrow belt across Africa just south of the Sahara. In some areas, such as countries bordering the Mediterranean, it is still a common summer visitor, and its purring 'turr turr' song remains widespread and familiar to many people.

This species has played a significant role in folklore and mythology since ancient times, and it has become a symbol of devoted love and loss in literature. Unfortunately some populations of European Turtle-Doves are in steep decline, especially around the northern and western fringes of its range. The main reason for the decline is thought to be the modernisation of agricultural methods, which directly affect the food supply of the birds, although large-scale hunting in some countries during the migration period has also played a part.

■ The purring disyllabic *turr turr* song is one of the key elements of the soundscape in many types of open woodlands on warm, sunny summer days.

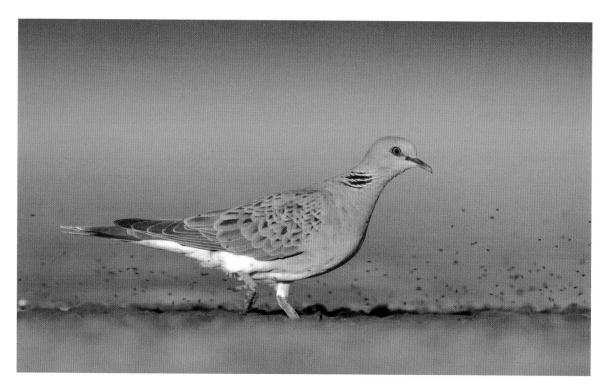

23 | **Grey-fronted Green-Pigeon**
Treron affinis

When hearing this extraordinary sound emanating from the canopy of a huge fig tree you would probably think that is being delivered by an obscure songbird, but in fact the beautiful, complex whistle comes from the Grey-fronted Green-Pigeon – a handsome-looking species that lives in the forests of the Western Ghats in Peninsular India.

Similar whistled songs, which are dramatically different from the cooing, purring and booming sounds one would expect to hear from the great majority of pigeons and doves, are a common feature of all 31 species of green-pigeons that occur mostly in Asia but also in Africa.

In addition to the fantastic song, the Grey-fronted Green-Pigeon is also a very attractive looking bird, with the male showing mostly pear-green body plumage, some yellow streaks on the wing-coverts, a chestnut vent and a dark maroon mantle. The female has slightly more subdued plumage and lacks the maroon mantle of the male.

■ The fantastic, most unpigeonlike whistled songs of the Grey-fronted Green-Pigeon.

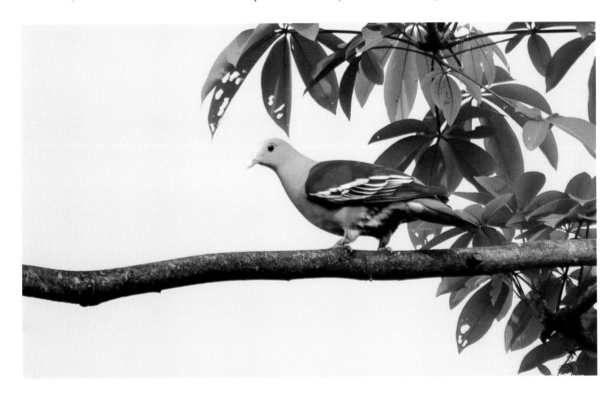

Asian Koel
Eudynamys scolopaceus

This is a well-known species of cuckoo, thanks to its loud, easily recognisable song, its tendency to live in cultivated areas near humans, and its wide distribution across most of Asia. Forms of koel occurring in Sulawesi, New Guinea and northern and eastern Australia are often treated as separate species, but they all share the trademark song.

The name koel is onomatopoeic in origin and derives from the species' song. Koels are very vocal during the breeding season, especially in the early hours of the day. Like many other cuckoos, this koel is a brood parasite that lays its eggs in the nests of crows and other hosts, who raise its young. Being well-known birds with loud calls, koels are a widely used symbol in Indian folklore, mythology and poetry.

■ The familiar song of the male is a repeated *koo-el* and the female utters a shrill *ki-ki-ki*.

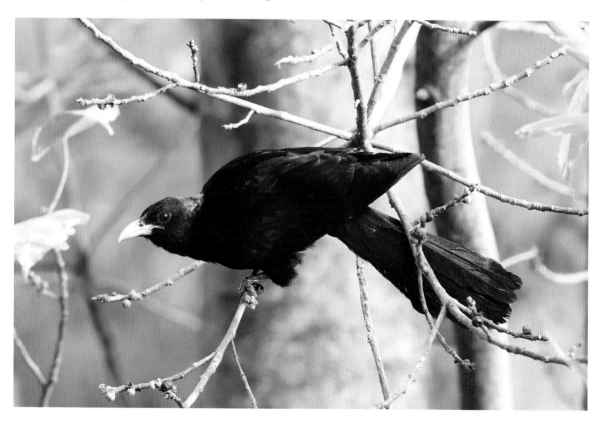

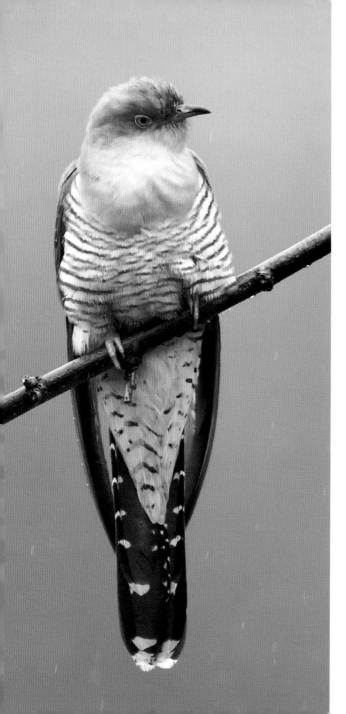

25 | **Common Cuckoo**
Cuculus canorus

The Common Cuckoo is a widespread summer visitor to Europe and Asia, inhabiting a variety of habitats from lowland forests to mountain slopes. Its song, which is audible for long distances, is probably one of the most well-known avian vocalisations, being the origin of not only the species' own name, but also the name of the entire cuckoo family, which is derived by onomatopoeia from the song of the male Common Cuckoo.

This cuckoo has found its place in many fairytales, songs and legends across its vast distribution from Europe to Japan. In Europe, hearing the call of the Common Cuckoo is regarded as the first harbinger of spring or summer. Also, being a brood parasite and laying its eggs in other birds' nests, it is also considered a symbol of infidelity and selfishness.

■ The iconic, repetitive *cuck-oo* song of the male.

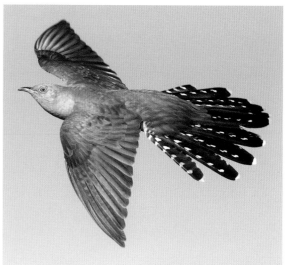

26 | **Mottled Wood-Owl**
Strix ocellata

A very attractive medium-sized owl with delicately marked plumage that closely matches the pattern of the bark of the trees it favours as a roosting place during the daytime. At night the Mottled Wood-Owl patrols its territory of open wooded plains in lowland India for food and, when need be, to maintain contact with its mate and keep potential intruders away from the territory.

■ These owls utter two main calls – an impressive hooting sound and a quavering call. This recording of a pair of wood-owls was made in the middle of a pitch dark night on the outskirts of Tala village in Madhya Pradesh. It included an additional fear factor due to the fact that one of the best tiger reserves in India was just a stone's throw away, and wandering young tigers are known to visit the village regularly in search of easy prey.

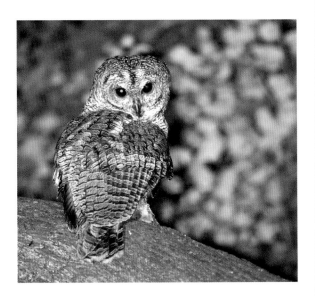

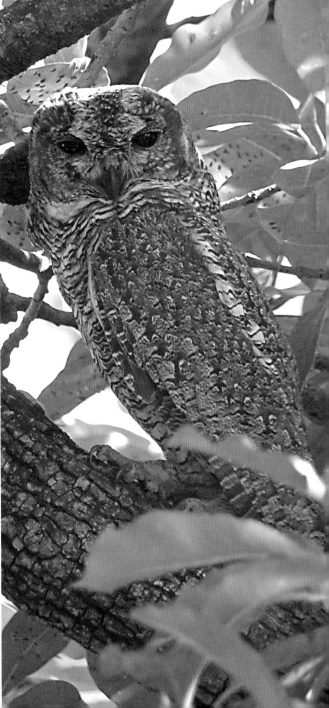

Tawny Frogmouth
Podargus strigoides

Widely distributed in Australia, the Tawny Frogmouth lives in a variety of usually rather open, dry woodlands and forests, but will even inhabit city parks and gardens with trees. It has a cryptic plumage, which is rather variable and depends on geography, sex and the individual bird. This camouflage helps the frogmouth to blend in amazingly well as it perches on a tree stump, sapling or the branch of a tree, where it sits motionless during the daytime.

As with all frogmouths, this species becomes active after sunset when it starts searching for food, which includes large insects and other terrestrial invertebrates. Another night-time activity of frogmouths is to keep singing and calling in order to advertise and defend their territories.

■ The Tawny Frogmouth has a variety of calls. The song is a magnificent, deep *uump uump*, repeated up to 50 times in succession, and provides the easiest means to locate this wonderful bird.

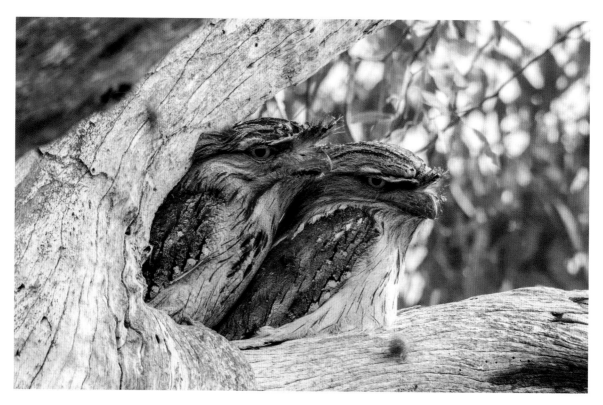

Common Potoo
Nyctibius griseus

The strange-looking Common Potoo, with pale greyish to brown body plumage decorated with fine black and buff patterns, lives in the forests of tropical Central and South America. Like nightjars and frogmouths, which it is related to, it is a nocturnal species and spends the daytime sitting motionless in a well-chosen spot, where its cryptic plumage and upright pose make it look like a log or the broken branch of a tree – the perfect camouflage to help protect it against predators!

During the night the potoo searches for insects by sitting on exposed perches and sallying after prey like a gigantic flycatcher. Its diet include all kinds of flying bugs.

■ Probably the best way to locate this master of camouflage is to listen for its mysterious, soft, and melancholic song, which is most often heard just after sunset, at dawn, and on moonlit nights.

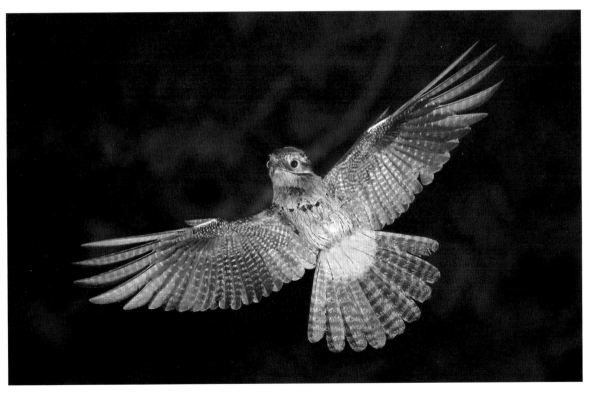

Laughing Kookaburra
Dacelo novaeguineae

To older readers the wild call of the Laughing Kookaburra came to symbolize the sound of the African 'jungle' in the early Tarzan movies made in the 1930s and 1940s. These were set somewhere in darkest Africa, but were actually shot in the USA, where the makers got their bird sounds a little confused! More recently the call has continued to be used regularly as a sound effect in situations that involve a jungle setting, including the 1997 film *The Lost World: Jurassic Park*.

In real life the Laughing Kookaburra, a kingfisher species measuring up to 42cm (16in) in length, is a formidable-looking predator boasting a huge dagger-shaped bill and dark highwayman's mask. It is native to eastern Australia and has been introduced to Tasmania, south-western Australia and parts of New Zealand, where it lives in dry open forest and woodland.

■ On this sample a duetting pair is giving their remarkable laughing song.

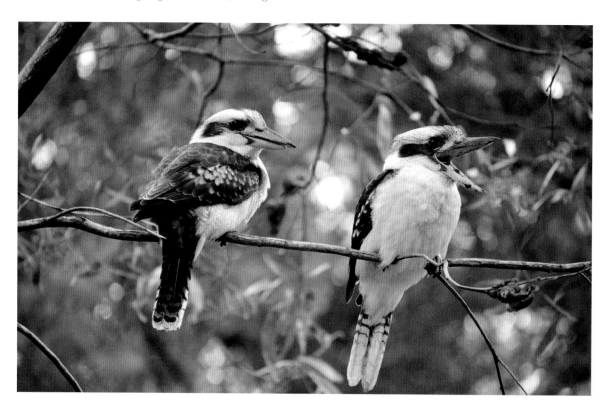

30 | **Great Hornbill**
Buceros bicornis

This huge, attractively decorated species of hornbill, with a body length of 95–130cm (37–51in), a wingspan of up to 150cm (60in), and a powerful decurved yellow bill with a massive casque on top of it, is a truly majestic sight. It lives in the mature forests of Asia and is declining due to habitat destruction and hunting for its strange bill, which is used for decorative purposes by local people. Big birds often make big sounds, and the Great Hornbill is no exception.

■ First you will hear single groans of a bird calling well before sunrise, with the bubbling song of the Asian Barred Owlet (*Glaucidium cuculoides*) in the background. Following that are the antiphonal calls of a pair of Great Hornbills, and finally very powerful wing noise, created by a series of deep wing flaps alternating with short glides, of a bird that flies overhead and perches in a tree some distance away.

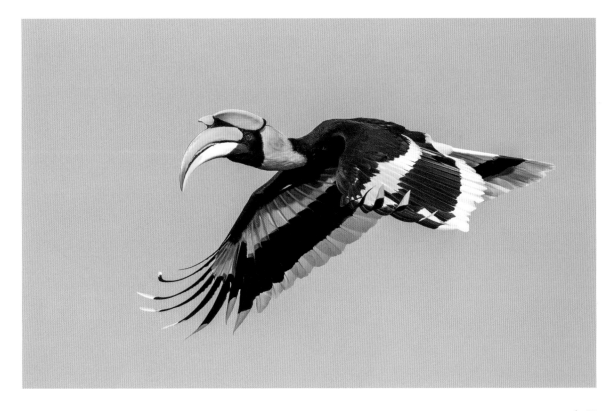

31 | **Coppersmith Barbet**
Psilopogon haemacephalus

Asian Barbets belong to the order Piciformes, which contains woodpeckers and their allies. At first glance it might be difficult to see the connection between barbets and woodpeckers, but in fact there are quite a few structural similarities such as zygodactylous feet (two toes pointing forwards and two toes pointing backwards) and similar tongue structure. They also share the habit of breeding in cavities.

The Coppersmith Barbet is widely distributed in the Oriental region and is probably the most abundant of all the 35 species of Asian barbets. It favours drier, more open habitats than many other barbets, and occurs in villages, suburbs, gardens and parks.

■ Thanks to its very distinct vocalisation, it is one of the better-known bird species in the region, and an integral part of the soundscape around human habitation. The Coppersmith Barbet was named after its distinctive song, which is supposed to remind the listener of the sound of a tinkering coppersmith.

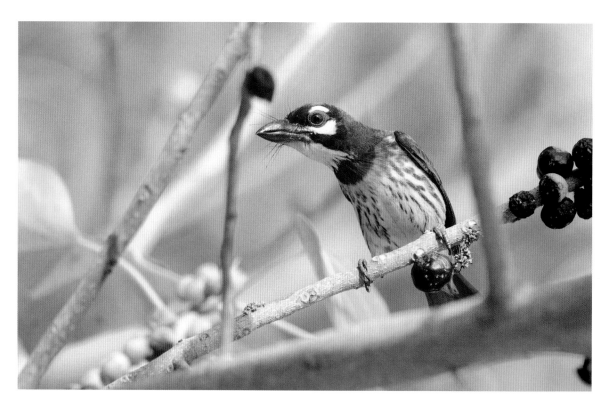

Black Woodpecker
Dryocopus martius

One of the largest and most charismatic of the woodpeckers and a species which is widely distributed across Eurasia. The woodpeckers and their allies, which comprise more than 200 species, occur in forested areas throughout the world, being absent only from Australia and New Zealand. Although they come in many plumages and sizes, many of them share a trait known as 'drumming'. Drumming is a non-vocal, mechanical sound produced by a woodpecker, which gives an extremely rapid rain of blows at a selected point of a tree – often a place with good resonant properties – creating a harsh, loud, vibrating sound. Drumming is used for territorial defence and attracting a mate. Each species of woodpecker has a species-specific rhythm of drumming.

■ First some loud drumming, then excited courtship calls, and finally some contact calls of a Black Woodpecker.

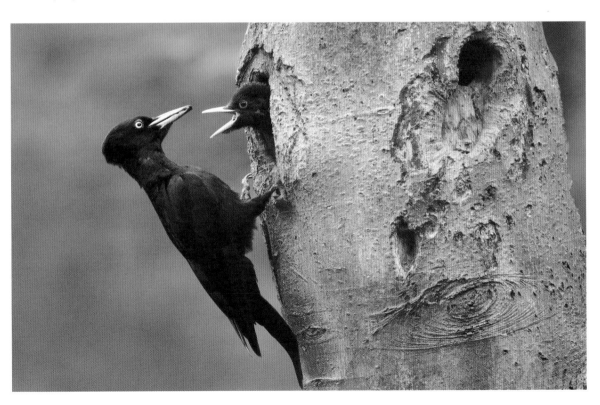

Screaming Piha
Lipaugus vociferans

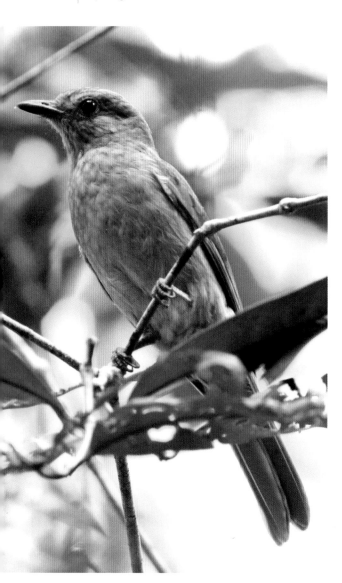

A rather nondescript and uniformly plumaged member of the cotinga family that has a wide distribution in the humid forests of the Amazon area and tropical parts of Mata Atlântica in South America. It would go largely unnoticed amongst the many amazingly bright bird species without its extraordinary and extremely loud voice. Its song, which carries for long distances through the dense forest, is one of the most commonly heard sounds in the Amazon, and forms the basis for many of the bird's local tribal names, such as 'pwe-pwe yoh' and 'kwow-kwee-yo'.

The outstanding song of the Screaming Piha is also frequently used in movies, and it has even appeared as a background sound in one of the 'Angry Birds' video games. Male Screaming Pihas display at large, loose leks, usually in groups of up to 25 males, where the distance between the individual males is about 40–60m (130–200ft).

■ The screaming song which is familiar in forests throughout the Amazon basin.

34 | **Capuchinbird**
Perissocephalus tricolor

The Capuchinbird belongs to the cotinga family – a diverse group of South American forest birds which includes many odd-looking feathered creatures that show extravagantly ornamented and unusual male plumages with curiously modified feathers or bright patches of bare skin. The Capuchinbird is no exception to this. It has a rather dull brown body plumage, but its legs and the odd-looking area of bare, featherless skin on the face and crown are bright bluish, while the upright feathers on the back of the head form a pronounced 'cowl'. In addition to this, the bird has a very special loud 'mooing' song, which the males deliver during a bowing performance on a lek. Male Capuchinbirds gather together on a communal display arena in the lower canopy of a tree, where the dominant male, surrounded by several subordinate males, does its best to attract and court visiting females.

■ The loud 'mooing' song of the male.

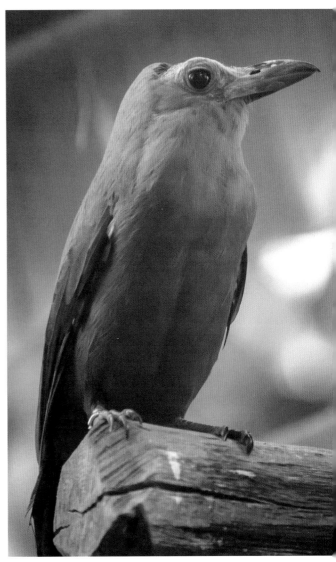

Superb Lyrebird
Menura novaehollandiae

With its large size, long filamentous tail feathers, long legs and terrestrial habits, the Superb Lyrebird brings to mind an odd-looking pheasant, but it is actually an oversized passerine. Despite living in a rather restricted area of south-east Australia and Tasmania, it must be one of the world's best-known songbirds, portrayed in numerous nature documentaries on TV. The spectacular, loud and complex song of the male consists largely (70–80 per cent) of imitations of local nature sounds, mostly of birds, which are mixed with some species-specific elements. Some individual lyrebirds have become famous for mimicking artificial sounds such as those of a chainsaw, the motor drive of a camera, or human whistles, but this is actually quite a rare phenomenon among wild lyrebirds.

In addition to its song, the male Superb Lyrebird has a spectacular courtship display, which is presented on an earthen dancing mound, where it thrusts its fanned, shivering tail forward over its back and head.

■ Listen to the song of the male Superb Lyrebird, which is filled with mimicry of other bird species.

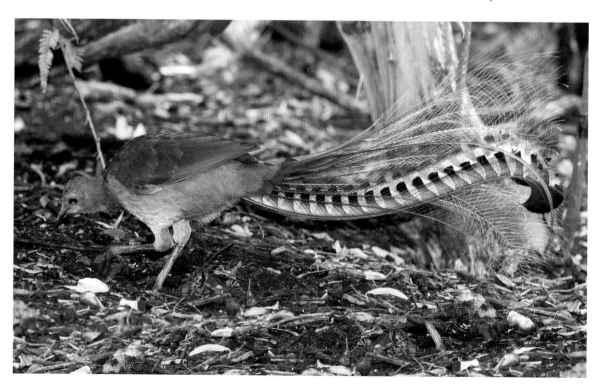

Spotted Bowerbird
Chlamydera maculata

This boldly spotted bowerbird with a small pink nuchal crest lives in the woodlands of interior eastern Australia. Like its congeners, the male guards an avenue bower, which is made of sticks and grass stems and decorated with items such as snail shells, bleached bones and pebbles. The bower functions as a courting arena and is the centrepiece of the male's life.

In addition the male has a repertoire of exotic hissing, crackling and ticking sounds which, combined with imitations of any other sound it hears, is used for courtship and territory defence. In fact the Spotted Bowerbird has sometimes been ranked as the finest of all the Australian mimicking birds. In addition to avian mimicry, sounds such as the barking of dogs, the noise of cattle breaking through the bush, emus crashing through twanging fence wires, woodchopping and the crack of a stock whip have been heard in its repertoire.

■ The male's song, including hissing, crackling and ticking sounds together with mimicry.

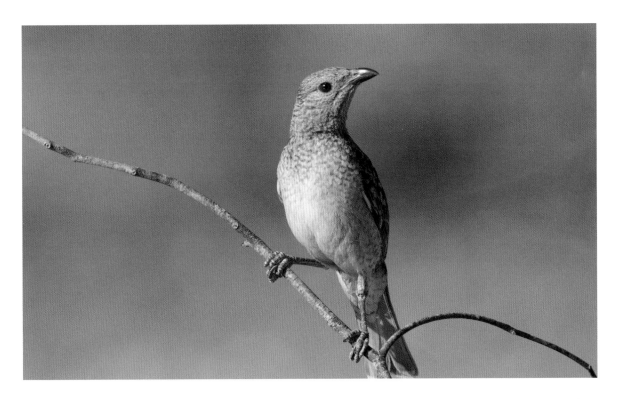

New Zealand Bellbird
Anthornis melanura

This rather modest-looking bird, with olive-green plumage and a red eye, is still a relatively common endemic species on both the North and South Islands of New Zealand, where it lives in native and exotic forests, scrub, parks and gardens. Unlike many of New Zealand's other native bird species it seems to cope quite well with introduced predators such as rats and stoats, and also with introduced wasps which compete for food.

The bellbird's song varies regionally, but always contains clear, liquid, ringing bell-like notes. Its song forms a significant component of the famed New Zealand dawn chorus that was much admired by early European settlers, and its song was described by the explorer Captain Cook "to be like small bells most exquisitely tuned".

■ A morning chorus of bellbirds on the island of Tiritiri Matangi off the north-east coast of New Zealand's North Island.

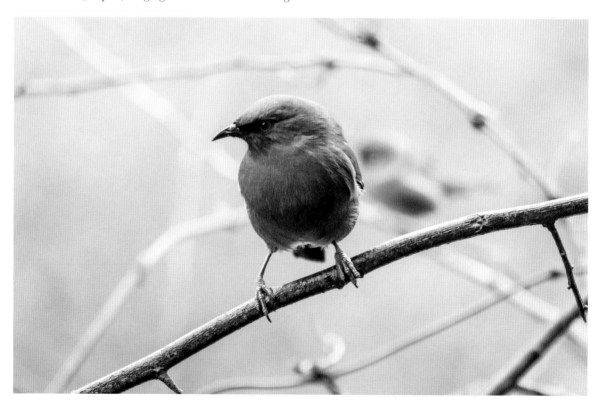

Chiming Wedgebill
Psophodes occidentalis

This rather dull-looking bird, with dark grey-brown upperparts, paler underparts and a distinctive forward-curving crest, is widely distributed in the arid areas of central and western Australia. It is not rare but due to its shyness and retiring way of life inside thickets it is often overlooked until it pops up on top of a bush and starts singing. The distinctive monotonous song, which can go on for the whole day, is one of the main components of the soundscape in the arid bush.

The species' name is derived from the loud song which consists of a series of chime-like notes. The Chiming Wedgebill was earlier considered to be conspecific with the morphologically very similar Chirruping Wedgebill, but they are now separated into different species on the basis of the very different vocalisations, and also the fact that pairs of Chirruping Wedgebills duet regularly – a behaviour that is not observed in Chiming Wedgebills.

■ The loud song consisting of 4–6 descending chime-like notes repeated incessantly.

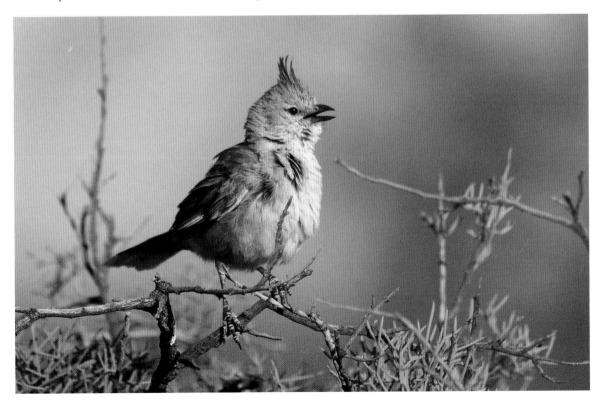

39 | **Pied Butcherbird**
Cracticus nigrogularis

A striking-looking bird with a black head, a black-and-white body and a long, robust bill. It lives in various open woodland and forest habitats, including farmlands and parks with mature trees, and is a common sight in many parts of Australia.

The Pied Butcherbird is a most accomplished singer, and it is often fed and tamed by people, in part for the sake of its superb song. It has three main song types: a territorial song, which is heard all year round during the daytime; a breeding song, which is heard during the breeding season at dawn and during the night only; and a continuous, quiet 'whisper song', which may last for tens of minutes and often includes mimicry of other birds.

■ On this recording you will hear the territorial song with slowly delivered flute-like notes – a beautiful, other-worldly sound.

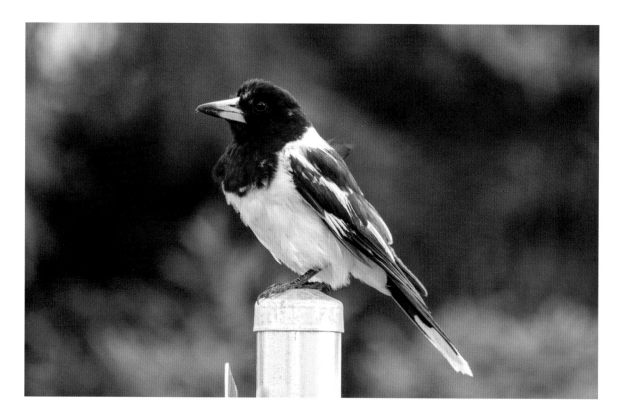

Crested Bellbird
Oreoica gutturalis

The Crested Bellbird is a rather common and widely distributed bird in drier wooded areas throughout most of Australia. It is the size of a Common Starling, with a sturdy bill, strong legs and mainly dull greyish-brown plumage. The male has a distinct white face and throat fringed by a black band, and a black erectile crest. The female lacks the contrasting head pattern of the male.

The distinctive song of the Crested Bellbird is one of the best-known and most typical bird sounds in the drier parts of Australia. The Aboriginals have given the species many onomatopoeic names, which aptly capture the essence of the song, such as 'wunnbunnpullalla' and 'panpanpalala'. This species has been declining recently due to habitat loss and habitat fragmentation.

■ The song of the Crested Bellbird. As the bird's name suggests, the song has a ringing quality that has been likened to the sound of a cowbell or to a sound made by a stone dropped in a pool.

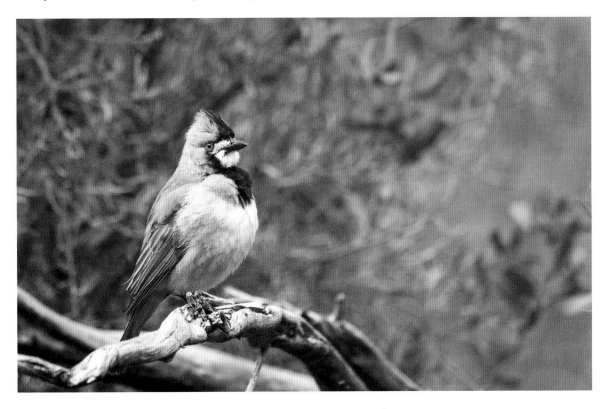

Greater Hoopoe-Lark
Alaemon alaudipes

An unusual-looking lark that lives in some of the most barren parts of the Sahara and other desert and semi-desert areas from the Cape Verde Islands through North Africa and the Middle East to Pakistan. Thanks to its long-legs and long decurved bill the Greater Hoopoe-Lark is well adapted for chasing invertebrates and digging them out of soft desert sand, and the fact that it doesn't require drinking water helps too.

The mostly dull brown body plumage blends into the sandy soil of the birds' environment remarkably well, and they go largely unnoticed until they start their characteristic flight display, where the bird climbs slowly up into the air flashing its distinctive black-and-white wings and black tail before tumbling down on closed wings. To perfect the show all parts of the flight display are accompanied by a beautiful song.

■ Very fitting piping sounds and trills, which together form a most pleasing melodious and yet rather melancholic song.

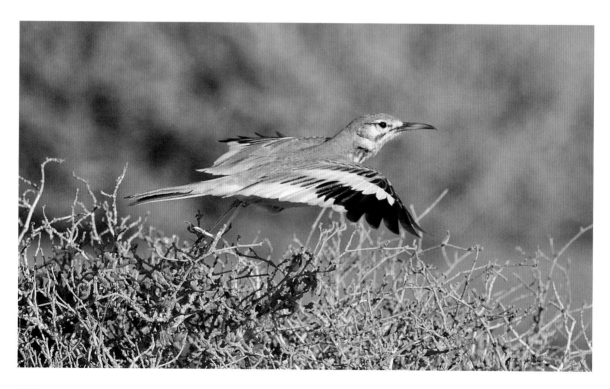

Eurasian Skylark
Alauda arvensis

A bird that is widely distributed across Eurasia's open habitats, including meadows, steppes, heaths and agricultural areas, and has also been introduced by humans to places such as Australia, New Zealand and Hawaii. In southern Asia it is replaced by the closely related Oriental Skylark (*Alauda gulgula*), which has a very similar song and outlook.

The Eurasian Skylark is probably the most famous aerial singer and certainly one of the most impressive. In its song flight, which may last for more than half an hour, it climbs higher and higher on fluttering wings that carry it far above the ground, where it remains at a height of 50–100m (150–300ft) and can be very difficult to spot from the ground. The birds also sing from the ground or from a perch such as a fencepost. The whole idea of the performance is to optimise sound transmission in an open habitat, and perhaps also add a conspicuous visual component to the song. In the northern part of their breeding range the arrival of flocks of skylarks is one of the early signs of the approaching spring.

■ Beautiful, varied warbling song which can be ongoing for more than 30 minutes.

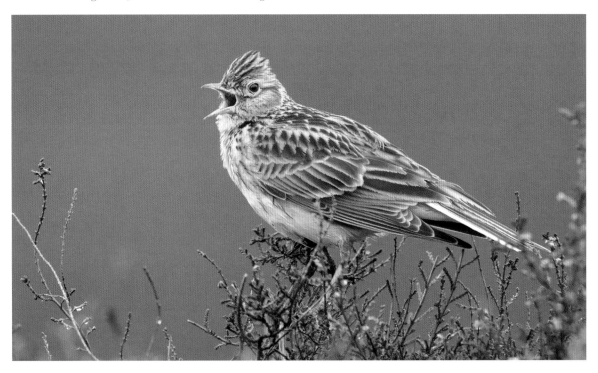

Barn Swallow
Hirundo rustica

Breeding across the Northern Hemisphere and wintering in the tropics of Asia, Africa and South America, the Barn Swallow is the most widespread member of its family and one of the most widespread of all the world's bird species. It is strongly connected to humans, especially during the breeding season, as it almost invariably breeds in buildings, often in places near livestock where there are plenty of flying insects around to provide a source of food.

Due to its close relationship with humans, the swallow has found its way into folklore, literary and religious works, and it is a much appreciated sign of the summer's approach in the north. In addition it is the national bird of Estonia. For us humans the warbling song of the male Barn Swallow is simply enchanting, but for other Barn Swallows it includes important clues about the condition of the singer.

■ First you will hear a singing male, then a noisy flock of migrating birds sitting on telephone wires.

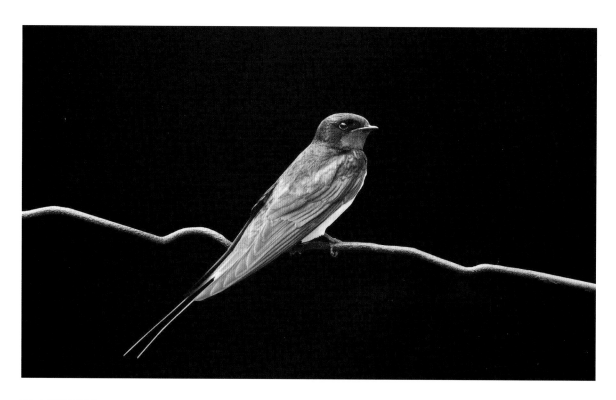

Yellow-bellied Bush-Warbler

Horornis acanthizoides

This small and elusive bird lives at 2,000–3,600m (6,500–11,800ft) above sea-level in the mountains of China, in ringal bamboo and less often other dense thickets within forests or under remnant trees. Like other species in the *Horornis* genus of bush-warblers it is small and looks pretty plain, with brownish wings and some yellowish wash on the belly that help to separate it from the other species.

It is rather shy and goes largely unnoticed as it goes about its business in dense undergrowth, until it starts singing and reveals itself through its remarkable, loud and prolonged song, which can last for about 40 seconds. When listening to it you really start to wonder how a mere 10cm (4in) long warbler is able to produce such a remarkable sound.

■ The truly remarkable, very prolonged, exceptionally distinctive, outlandish and powerful song. You can hear one full strophe of this songster, which was recorded on Wawu Mountain in Sichuan, western China, in May 2006.

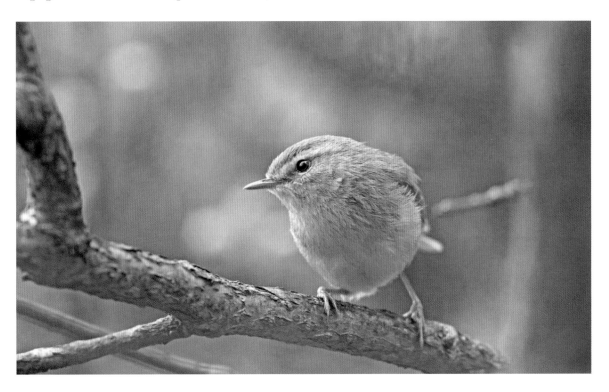

Willow Warbler
Phylloscopus trochilus

This small leaf warbler breeds throughout northern and temperate Eurasia, from Ireland in the west to eastern Siberia in the east, and the entire breeding population from across Eurasia migrates to Sub-Saharan Africa for the winter.

The Willow Warbler breeds in a wide variety of open woodland habitats and is one of Europe's commonest breeding birds, with the highest population densities found in Scandinavia. It is a small, modest-looking bird with some yellowish on the breast and face and greenish upperparts, and it is very difficult to separate from some other closely related species of leaf warblers in the genus *Phylloscopus*, such as the Common Chiffchaff and Wood Warbler. That is until it opens its mouth and delivers its soft, melodious, somewhat melancholic song, which is one of the sweetest of all birds in the north and a telltale sign that summer is finally approaching after a long and harsh winter.

■ The song begins with a trill and becomes a cascade of soft notes descending down the scale.

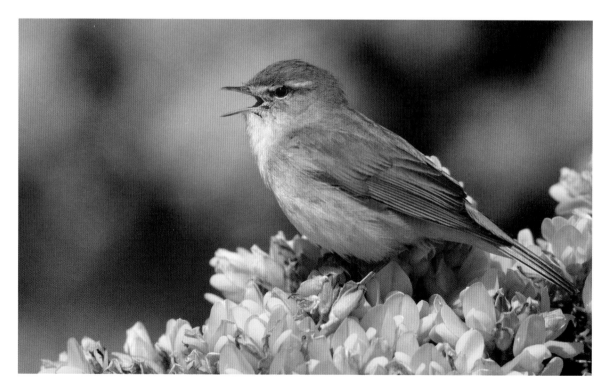

Blyth's Reed Warbler
Acrocephalus dumetorum

A species which breeds across the temperate zone of Asia and all the way to the shores of the Baltic Sea, wintering in the Indian Subcontinent and Myanmar. Together with the Marsh Warbler (*Acrocephalus palustris*, No. 47) and several other species in the reed warbler genus *Acrocephalus*, it belongs to a family that includes many masters of bird song.

Like the Marsh Warbler, the Blyth's Reed Warbler weaves into its songs imitations it has learned from other species of birds on its breeding grounds and probably also sounds heard on its wintering grounds in southern Asia, but as yet no one has really dug very deeply into this subject. In areas where Blyth's Reed and Marsh Warblers occur side by side, birdwatchers often debate which of the two species is the better songster. Now is your chance to choose your own favourite!

■ The Blyth's Reed Warbler delivers its song at a slower, more leisurely pace than its hot-headed cousin the Marsh Warbler, and it recalls in some respects the song of the Song Thrush (*Turdus philomelos*, No. 59).

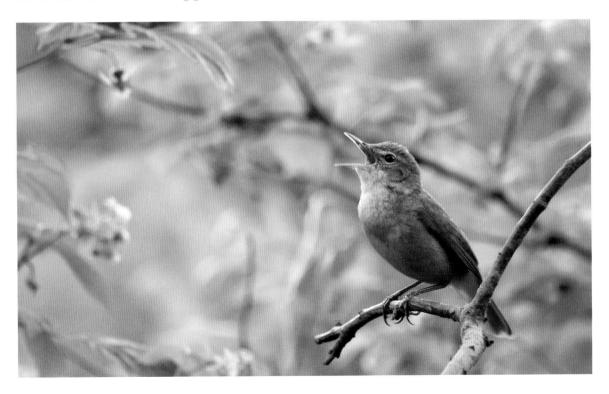

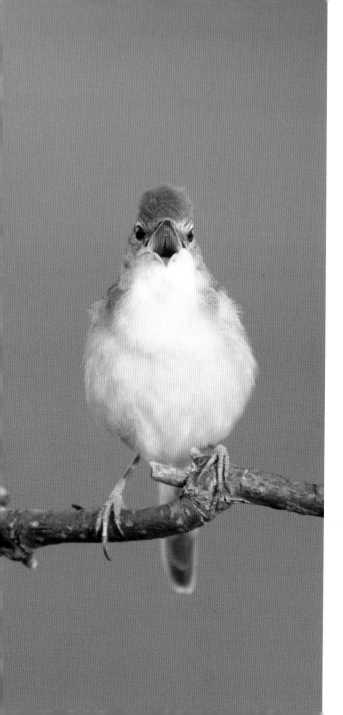

47 | **Marsh Warbler**
Acrocephalus palustris

The Marsh Warbler breeds widely in Europe and western Asia and winters in south-east Africa. It is a remarkable mimic and imitations of more than 200 different bird species have been identified in its song, including roughly equal numbers of European and African species. All the imitations are learned during the first year of a bird's life, and the repertoire remains unchanged for the rest of its life.

Each Marsh Warbler has an impressive individual repertoire, which contains hundreds of motifs belonging to 80 or more bird species, and it takes up to 35–40 minutes of continuous singing for the full repertoire to be heard. To identify the imitations, which are usually less than one second in length and recombined into complex motifs, requires expert skills on the part of the listener.

■ A Marsh Warbler in full song, complete with mimicry of a number of other bird species, for example at one point an easily recognisable series of calls of a distant Carrion Crow (*Corvus corone*) or Hooded Crow (*C. cornix*) can be heard.

Puff-throated Babbler
Pellorneum ruficeps

A species belonging to the large ground babbler family which is widely distributed and relatively common in the Indian Subcontinent and South-East Asia, where it inhabits the forest floor and understorey in broadleaved forest, secondary growth and bamboo.

When seen well, which unfortunately doesn't happen too often, it is actually quite an attractive little bird with a rufous cap, white supercilium and streaked breast and flanks. And yes, it puffs-up its silky white throat-feathers when it is agitated, hence the name. Due to its skulking way of life it usually reveals its presence by its vocalisations. These include a remarkably sweet and sprightly song, which will almost invariably bring a smile to an observer's face.

■ Puff-throated Babbler song and other frequently heard sounds, including the two- to three-note whistled advertising call and the chattering calls uttered here by a small group of birds moving on the forest floor.

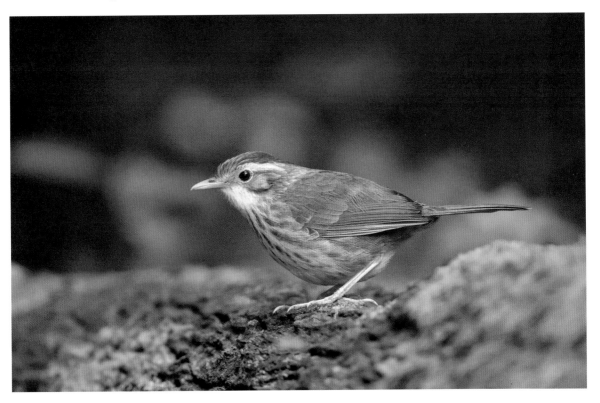

Chinese Hwamei
Garrulax canorus

The Chinese Hwamei belongs to a group of birds known as laughingthrushes, which includes many species that are accomplished singers. The name 'hwamei' comes from the Chinese language and means 'painted eyebrow', which is a reference to the distinctive marking around the bird's eye.

The species occurs across southern and central China, Vietnam and Laos. Because of its attractive song the hwamei is a popular cagebird in China and some other countries in Asia. In China it is a common sight to see people taking their pet hwameis in their small cages to city parks every morning in order to get some fresh air and practise singing with other hwameis. Also, song contests, where birds compete against each other for the title of best singer, are a popular pastime and the winning birds can be worth a lot of money.

■ The beautiful fluty whistling song of the Chinese Hwamei.

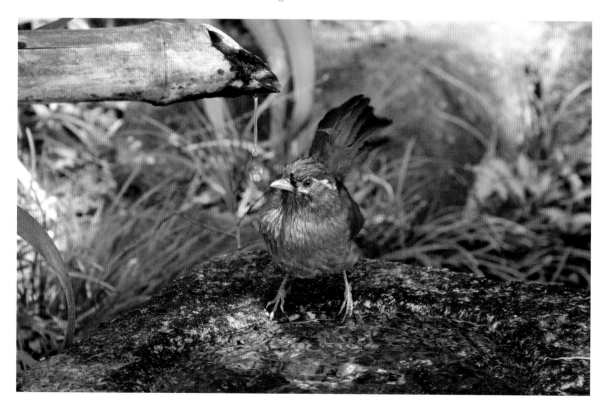

Eurasian Blackcap
Sylvia atricapilla

This species, usually known simply as the 'Blackcap', is a common and rather widespread warbler that breeds in mature deciduous woodlands in much of Europe, western Asia and northern Africa, with some populations moving further south to winter in Sub-Saharan Africa. The bird's name refers to the neat black cap of the male, while in the female and juvenile the cap is reddish-brown.

The beautiful song is a rich musical warble that has made the species popular among humans and has resulted in it featuring in literature, films and music.

The function of bird song is to repel rivals and attract potential mates. Some species have different song types for these two purposes, but it appears that for the blackcap different parts of the song perform these functions. The loud musical whistles play an important role in territorial conflicts with other males, while the quieter warble is used in interactions with females.

■ The musical warbling song that ends in a loud whistled crescendo.

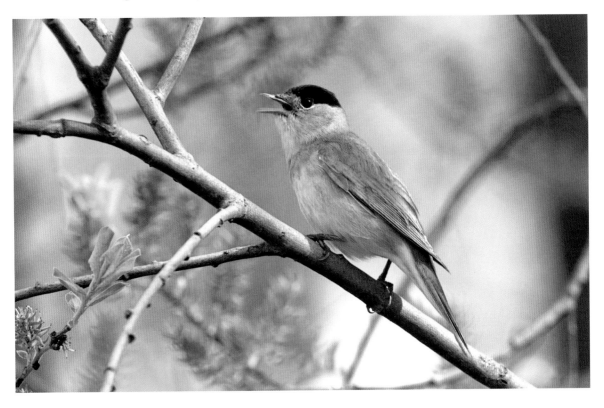

51 | **Spotted Elachura**
Elachura formosa

This tiny little bird, which has small white speckles on its brown upperparts, occurs in the mountain forests of the eastern Himalayas and South-East Asia. It has earned its place in this collection on the basis of its remarkably high-pitched and powerful song, which for us humans must rank as one of the top candidates in the category for most ear-piercing and irritating bird song, especially when heard from close range.

For the bird itself the piercing quality of its song is very useful as it needs to deliver its message through the dense undergrowth and over the noise of the streams that are a common feature of its habitat. Until fairly recently the Spotted Elachura was thought to be a member of a genus of wren-babblers, but it is now known to represent the only living member of a different bird family and it has no close relatives which are extant.

■ Phrases of the extremely high-pitched, shrill, piercing song.

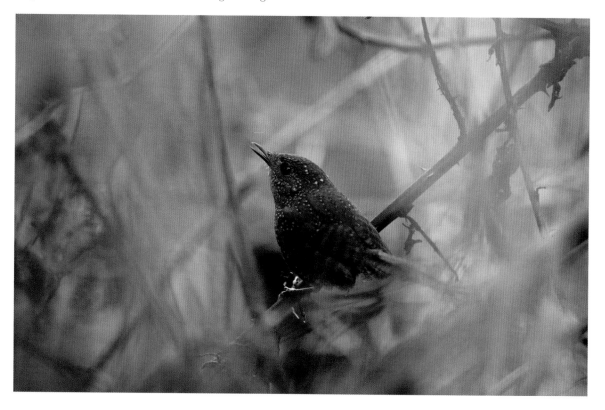

Eurasian Wren
Troglodytes troglodytes

This tiny but sprightly little species was until recently considered to have a range that encompassed Eurasia and North America, but it has been 'split' by ornithologists who now consider the North American populations to represent two separate species – the Winter Wren (*T. hiemalis*) in the east and the Pacific Wren (*T. pacificus*) in the west – largely on the basis of differing vocalisations.

Like its American relatives the Eurasian Wren has brown plumage with faint dark barring, a short stubby tail which often points upwards, and an amazingly loud song which consists of a twittering flow of sounds and causes the whole body of the singing bird to vibrate.

A young wren creates its own songs (there are usually several different versions) by listening to older birds and then recombining the learnt elements to form its own personalised song. The role of the wren in folklore and legend is extraordinarily widespread, especially in Europe. In many different cultures the wren is recognised as the 'king of the birds', and in a number of European countries its vernacular name implies royalty.

■ The loud song, which includes a series of warbling and twittering phrases delivered in quick succession.

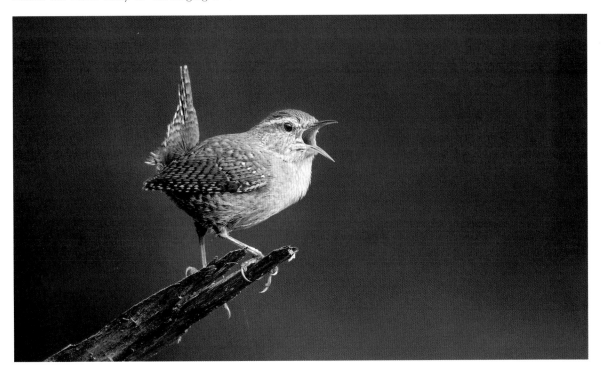

53 | **Northern Mockingbird**
Mimus polyglottos

The Northern Mockingbird occurs from south-east Canada across the USA to northern Mexico, and also on some of the islands of the Caribbean. Despite its rather featureless plumage, with grey to brown upperparts, paler underparts and white patches on the tail and wings, it has an influential role in North American culture, being the state bird of five states and appearing regularly in literature and many American folk songs.

Both sexes sing and the species is well known for its ability to mimic other birds, as is indicated by its scientific name, which means 'many-tongued mimic'.

The Northern Mockingbird is probably the best known, although not the most talented, of all the North American mimicking bird species, and it includes in its song repertoire not only the songs and calls of other birds, but also the sounds of other animals such as cats and dogs, together with artificial sounds such as car alarms.

■ Song of the Northern Mockingbird, including mimicry of other bird species.

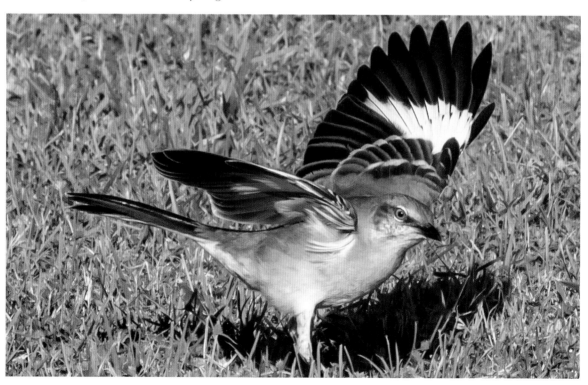

54 | **Brown Thrasher**
Toxostoma rufum

A long-tailed bird with a long, slightly decurved bill, long legs, rufous-brown upperparts and heavily streaked underparts. It occurs in eastern and central parts of the USA and southern and central Canada, and belongs to the New World bird family Mimidae, which also includes other acclaimed songsters such as the Northern Mockingbird and Grey Catbird.

Due to its habit of skulking in dense cover on or near the ground, the Brown Thrasher often remains undetected until it starts uttering its loud call notes or extraordinary song that is packed with phrases borrowed from other bird species. Detailed studies have shown that a male Brown Thrasher can sing more than 1,100 song types – one of the largest repertoires of any North American songbird.

■ The song is formed by a complex succession of musical phrases, which are typically repeated a few times before moving on, and include imitations of other birds such as Chuck-will's-widow (*Antrostomus carolinensis*), Wood Thrush (*Hylocichla mustelina*, No. 57) and Northern Flicker (*Colaptes auratus*).

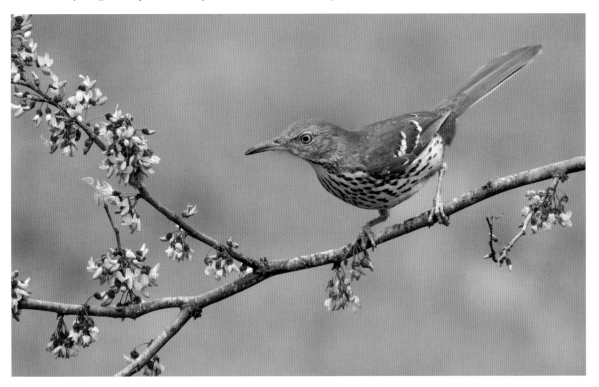

55 | **Common Starling**
Sturnus vulgaris

This species is widely distributed throughout northern Eurasia and has also been introduced to many other corners of the world, including North America, South Africa, Australia and New Zealand. It is well known for its song, which at first may sound like a random selection of whistles, mews, clicks and screeches, with the occasional imitation of a car alarm or another bird species. In fact, though, all starling songs follow the same set of rules: starting with whistles, followed by song types including the mimicry of other birds and sometimes sounds made by humans, rattles and squawks, and ending with high-pitched trills or screams.

Each male has a repertoire of 60–80 motifs, which each lasting 0.5–1.5 seconds. Each bird will increase the number of motifs in its song by directly imitating 'ear-catching' sounds its hears, or just learn them by listening to other starlings. A large repertoire of motifs is a sign of high fitness, and fitter birds produce more offspring.

■ The song of the Common Starling, beginning with a series of whistles, working its way through the other phrases explained above, and ending with high-pitched notes.

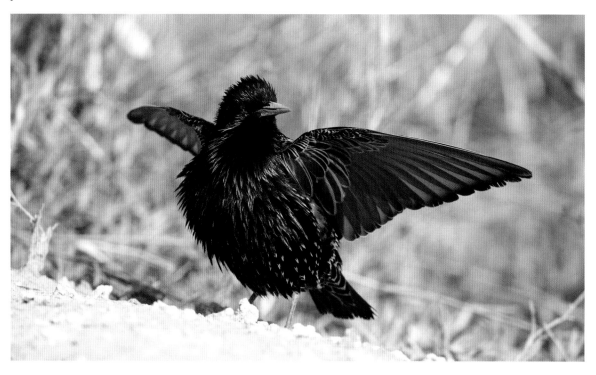

Townsend's Solitaire
Myadestes townsendi

A rather modest-looking, greyish bird with buffy wing-patches, a longish tail and a distinct white eye-ring. Measuring 20–24cm (8–9.5in) in length, it is placed with 10 other species known as solitaires in the genus *Myadestes*. Although they are part of the thrush family, solitaires share some features with flycatchers, including the habit of perching in an upright position, and the distinctive eye-ring.

The Townsend's Solitaire inhabits montane forests from Alaska to central Mexico and has one of the most specialised diets of any North American bird, at least during the winter time when it feeds almost entirely on juniper berries (which are actually a type of fleshy cone).

There are several highly acclaimed songsters in the solitaire family and the Townsend's is no exception. It usually sits on the top of a tree or bush when delivering its song.

■ The song comprises a series of rich warbles. Both male and female sing, but the song of the female is said to be softer.

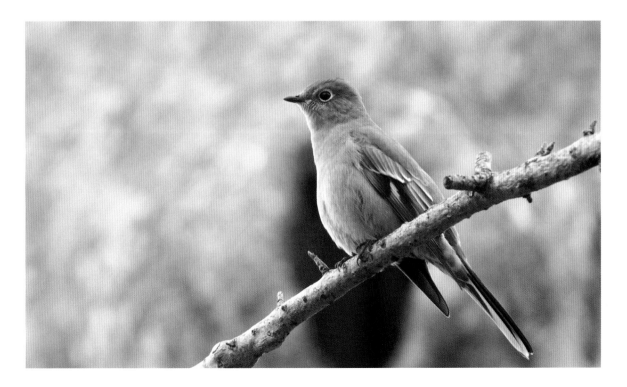

57 | **Wood Thrush**
Hylocichla mustelina

A widely distributed breeding bird across eastern North America, which winters in Central America and southern Mexico. It is closely related to the thrushes in the genus *Catharus*, which contains long-distance migrant species such as Veery and Hermit Thrush that breed in North America, together with the more sedentary nightingale-thrushes of Central and South America. This group of birds includes a number of highly acclaimed songsters, which in many people's minds compete for the title of best songbird, and among them the Wood Thrush's haunting, flute-like song is often cited as the most beautiful.

In recent decades the Wood Thrush has become less common in North America's eastern forests, and studies suggest a 50 per cent drop in numbers since 1966. One reason for this dramatic decline is probably the fragmentation of the forest habitats where the birds live, which gives predators such as domestic cats and nest parasites such as Brown-headed Cowbirds easier access to their breeding grounds and makes them more vulnerable to predation.

■ Samples of Wood Thrush song, with its beautiful flute-like tone.

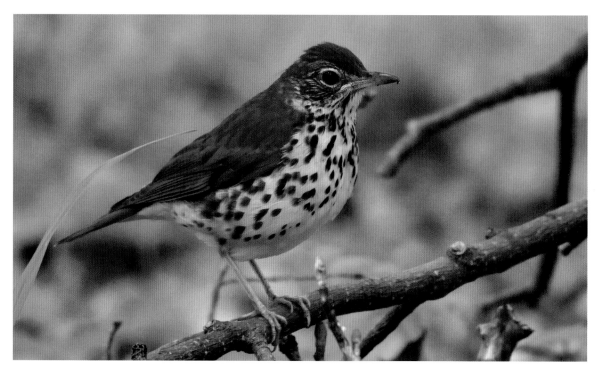

Common Blackbird
Turdus merula

The Common Blackbird or Eurasian Blackbird is widely distributed in Europe, the Middle East and North Africa, with its range extending east to western China and Mongolia. In addition its melodious song can also be heard in the whole of New Zealand, south-east Australia, and in many other corners of the world where it has been introduced by humans in recent centuries.

Native populations of blackbirds living in eastern Asia, on the slopes of the Himalayas and in the Tibetan Plateau look superficially similar to the Common Blackbird but sound quite different, which alone is a good reason to treat them as separate species.

The Common Blackbird's song is undoubtedly one of the sweetest of all Europe's songbirds, and has given rise to a number of literary and cultural references since ancient times. The species is also the national bird of Sweden.

■ Blackbird song with its rather melancholic mellow tone and clear and loud fluting delivered at a slow tempo and with a wide, often sliding, scale.

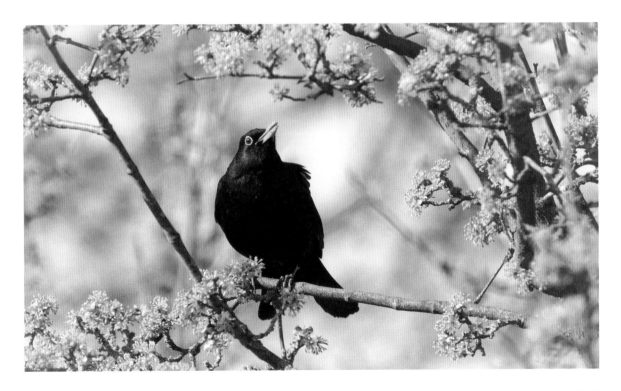

Song Thrush
Turdus philomelos

Another European thrush species that is held in high esteem for its beautiful song. It breeds across much of Eurasia and northern populations migrate to southern Europe, North Africa and the Middle East for the winter. Birds introduced, apparently for purely sentimental reasons, to New Zealand in the 1860s are now thriving, whereas birds taken to Australia persist only in a small area around Melbourne, Victoria.

The Song Thrush lives in many types of forests and woodlands, parks and well-vegetated gardens, but favours deep and dark spruce forests in northern Europe. It has a loud, rich, slowly advancing and variable song with the characteristic repetition of musical notes followed by a short pause before the next set of notes begin.

The song of the Song Thrush, which is best heard at dawn and dusk, is often referred to in poetry. Its old English names include 'Mavis' and 'Throstle'. The bird also appears in the emblem of West Bromwich Albion Football Club, and one of the club's nicknames is 'the Throstles'.

■ Song of the male including a variety of repeated phrases and notes.

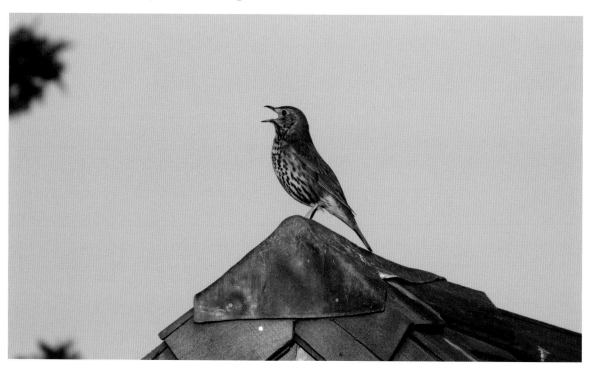

Oriental Magpie-Robin
Copsychus saularis

A common inhabitant of various semi-open forests in Asia, from India to western Indonesia. It is more common and more confiding than its close relative the White-rumped Shama, occurring around human habitation in gardens, suburbs, orchards, parks and towns. Its voice forms an essential part of the urban soundscape in many corners of Asia.

It is a well-known and much-loved songbird, producing an ethereal, sweet, thin, sibilant, tinkling, mid-pitched warble. There is a lot of individual variation in the structure of the song, and to human ears some birds sound more pleasing and appear to be more skilled songsters than others. In urban environments the best time to listen for the Oriental Magpie-Robin is usually very early in the morning, when its powerful song is often the only audible avian sound.

■ The beautiful warbling song of the Oriental Magpie-Robin.

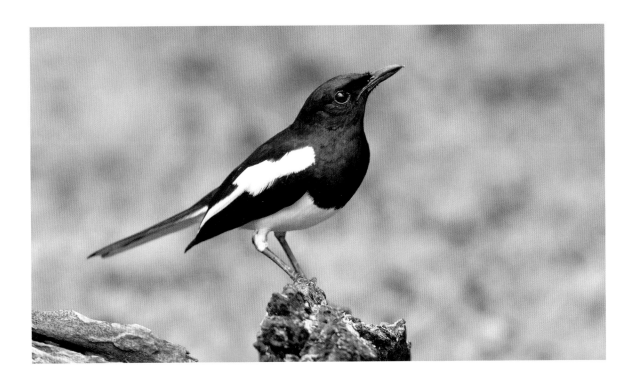

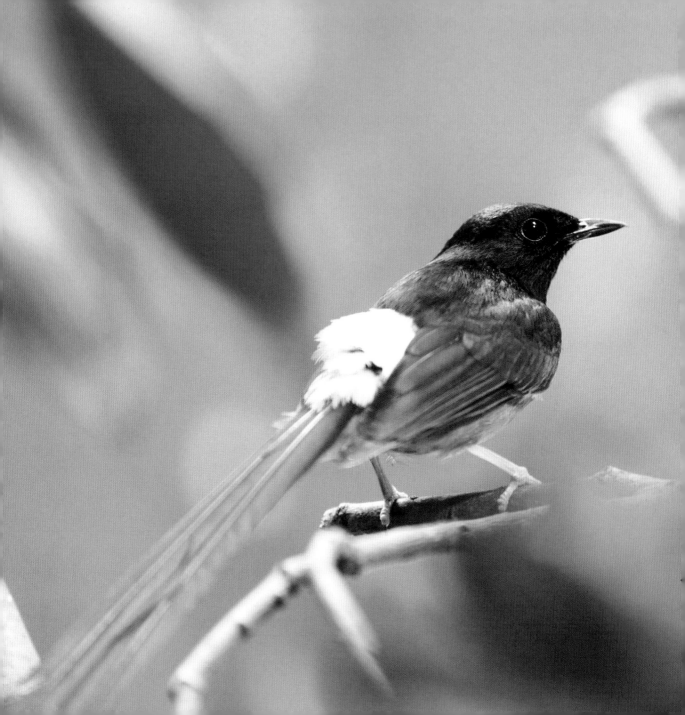

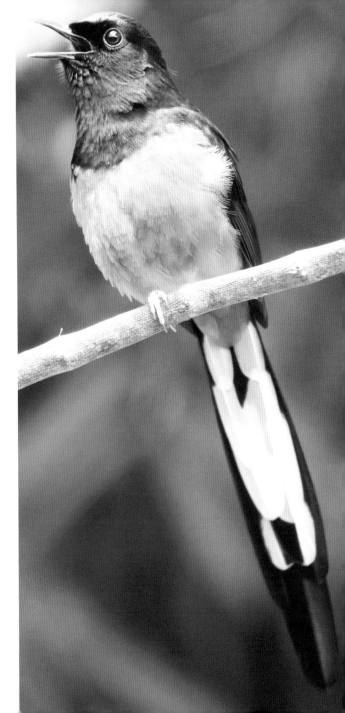

61 | **White-rumped Shama**
Copsychus malabaricus

This rather shy and retiring songbird lives in the jungles of Asia, from India to western Indonesia. Unlike many other great avian singers the male White-rumped Shama also looks good, with glossy black upperparts and breast, deep rufous underparts, a very long tail which is often held cocked, and a shiny white rump patch. It has an extraordinary casual but virtuoso song, which is highly varied and frequently includes mimicry.

An interesting historical event is connected with the song of this species. It is believed that the first-ever bird sound recording was made of this species in 1889 by Ludwig Koch (at the age of eight) with an Edison phonograph and wax cylinder which his father had purchased at the Leipzig Fair. The recording still survives and is preserved in the collections of the National Sound Archives in the UK.

■ The extraordinary song of the White-rumped Shama, which includes surprising bursts, mimicry, long trills, discordant notes and rich mellow whistles.

62 | **European Robin**
Erithacus rubecula

A widespread bird across Europe, western parts of Siberia and northern Africa, with northern populations migrating south for the winter and southern breeding birds being sedentary. It is a common bird throughout its range and especially well known in Britain, where it is resident throughout the year and has become a very confiding and much-loved garden bird. The species plays a prominent role in British folklore, and more recently (since mid-19th century) it has featured strongly as a subject on Christmas cards and as a symbol of Christmas.

Further north and east in Europe, robins are still common but are somewhat more retiring, tending to frequent coniferous forests where they are perhaps less often seen but still regularly heard and admired for their song. Robins will keep singing until late into the night and start again after only a couple of hours, well before sunrise. In some urban locations, where artificial lights are present, robins seem to be changing their behaviour and singing through the night.

■ The fragile and clear song of the European Robin.

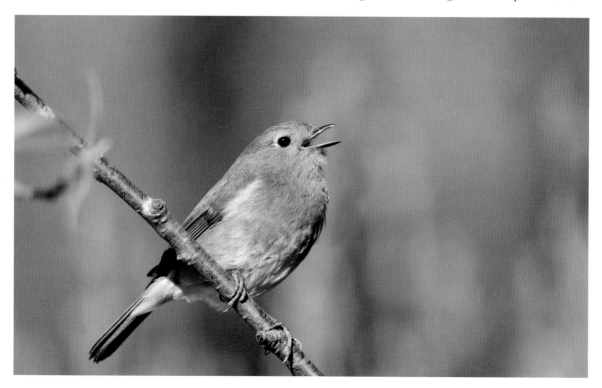

63 | **White-browed Robin-Chat**
Cossypha heuglini

This eye-catching bird is one of eight species of medium-sized robin-chats from Sub-Saharan Africa that belong to the genus *Cossypha*. They all share a number of features, including rufous-orange underparts, a mostly orange tail, often bluish-grey upperparts, and a very distinctive head pattern, with most species having some white and black plumage on the head.

All robin-chats are fabulous songsters, and they all share the loud musical, thrush-like song, but some of the species are more accomplished singers than others and they include a number of imitations in their songs such as those of other birds, small animals and even human whistles. Of all the robin-chat species, the White-browed Robin-Chat is the most widely distributed and it is generally common throughout its range.

■ Typical features of the song of the White-browed Robin-Chat include the repetition of an extended series of standard phrases, with each sequence increasing in volume and becoming more rapid and urgent.

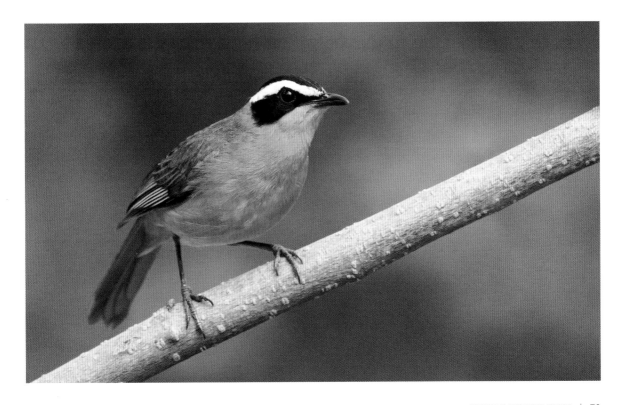

Bluethroat
Luscinia svecica

The male Bluethroat is a handsome-looking bird with an iridescent blue bib edged below by a black band and then a rusty-orange band. Depending on the geographical origin of the individual, there is a reddish or a gleaming white spot in the middle of the blue throat, or the bib is just uniformly blue. The female shows a more modest breast pattern with little or no blue or rust-red plumage at all. Birds of both sexes and all ages have diagnostic rust-red bases to the outer tail-feathers, which often show clearly when the bird is in flight.

In addition to its good looks the species has a very attractive and varied song, which includes a lot of mimicry – imitations of the vocalisations of 50 species of birds have been identified in Europe, along with the sounds of frogs and insects.

The Bluethroat breeds in low, dense vegetation with sufficient open areas, and its distribution extends as a broad band from Western Europe across Eurasia and all the way to western Alaska. Birds winter from Iberia and Sub-Saharan Africa through the Middle East and India to South-East Asia.

■ The beautiful warbling song, which includes a great deal of mimicry.

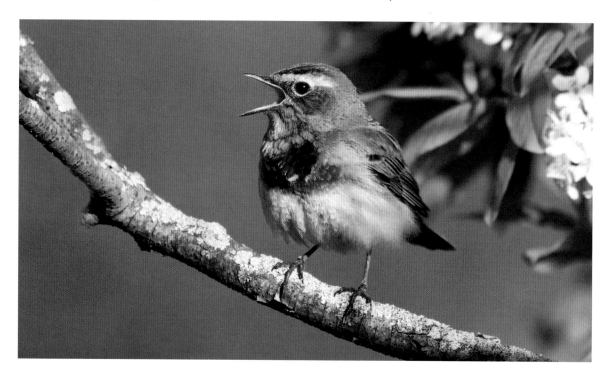

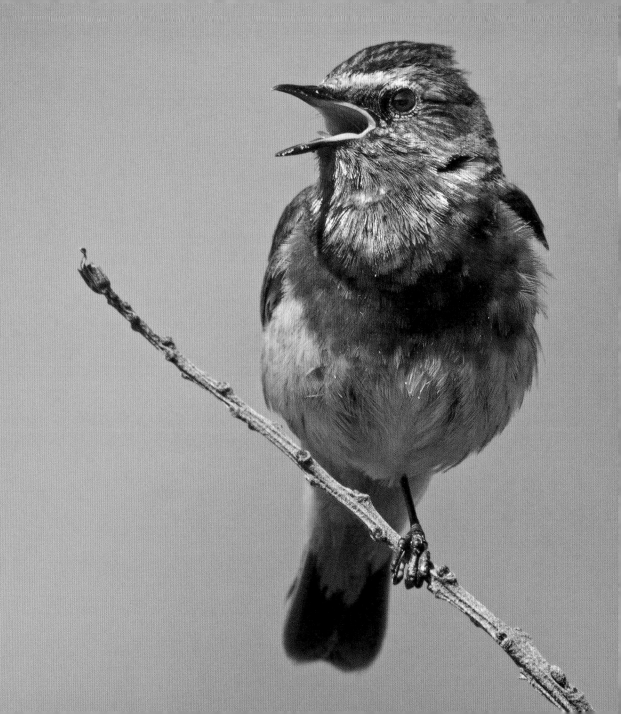

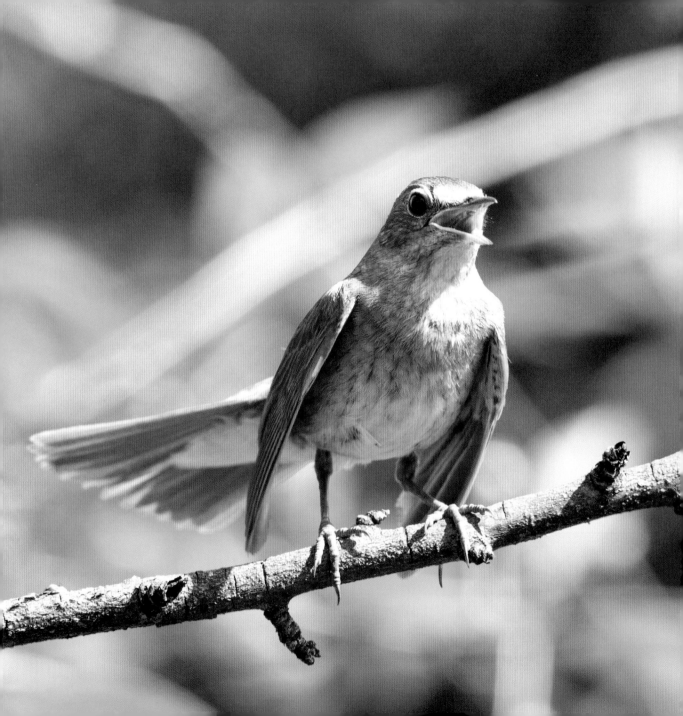

65 | Thrush Nightingale
Luscinia luscinia

This species occurs from northern and eastern Europe to western Asia, where it breeds in thick, damp, shady deciduous forest and thickly wooded parks and gardens. It is a summer visitor to its breeding grounds and winters in Africa.

Rather harshly the Thrush Nightingale has been said to be a less vocally pleasing substitute for the 'real' (Common) Nightingale of western and southern Europe, although many people living in its breeding range may disagree with this statement. You can form your own opinion by comparing these two species – the Thrush Nightingale here and the Common Nightingale on the following page (**No. 66**).

On still summer nights, when it does most of its singing, the remarkably powerful song of the Thrush Nightingale is audible for kilometres. If you are a light sleeper you definitely don't want this songster to perform under your bedroom window!

■ The Thrush Nightingale's song is perhaps more simple and less varied than that of the Common Nightingale, but it is presented with intoxicating power and intensity.

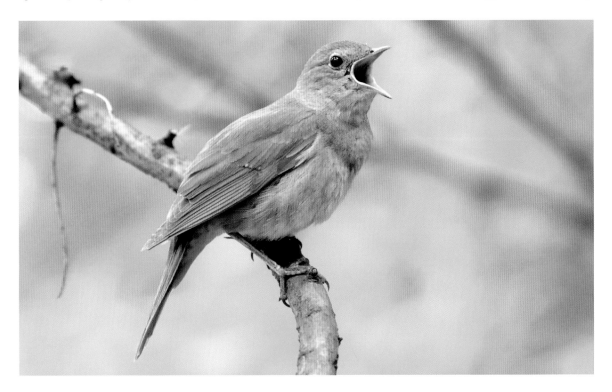

Common Nightingale
Luscinia megarhynchos

Common Nightingales breed in woods and groves from western, central and southern Europe to northern Africa and central Asia. The species is a summer visitor to its breeding grounds, escaping the harsh winter in the warmth of Sub-Saharan Africa. As a rather skulking bird it is more often heard than seen, and when it does show itself many observers are surprised by its somewhat plain appearance.

The nightingale has its own rich history of representation in literature and in the minds of everyday people. The history begins with one of the oldest legends in the world, the Ancient Greek tale of Philomela, the poor girl who had her tongue cut out and was changed into a nightingale, which laments in darkness but nonetheless expresses its story in song.

■ The powerful and melodic song, consisting of trilling sounds, fluted whistles and rippling or gurgling notes. It is considered by many people to be the most beautiful bird song, in Europe at least.

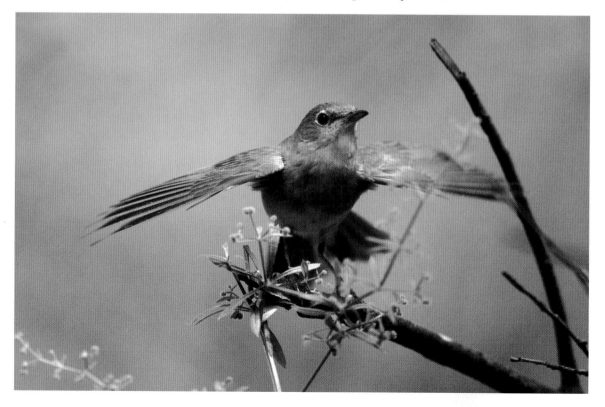

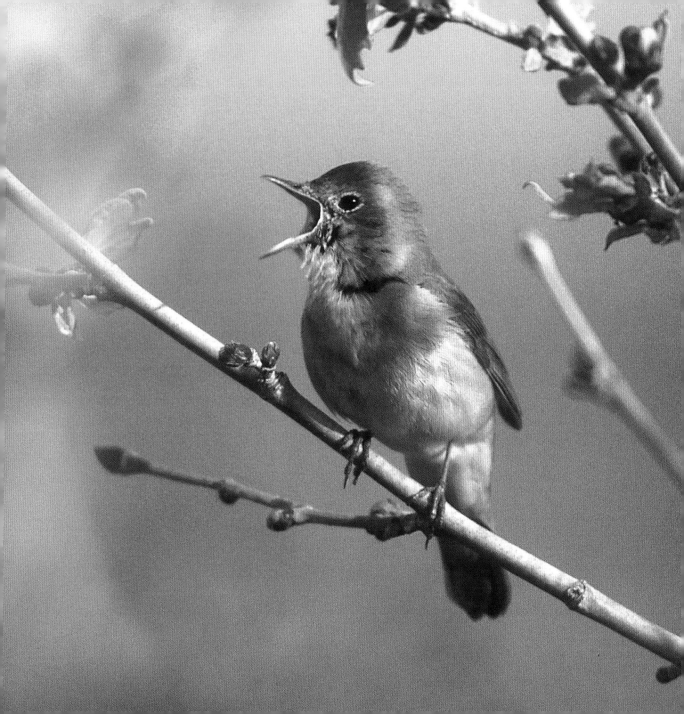

Siberian Rubythroat
Calliope calliope

A rather close relative to both European nightingale species, and it shares with them the rather modest and featureless plumage, except for the head pattern which shows a white supercilium and submoustachial stripe and, in the male, a bright red throat-patch which really does shine like a ruby when the light catches it from the right angle.

The scientific name *Calliope* comes from Greek mythology and means 'beautiful voice'. The Siberian Rubythroat's song can be heard in summer from the Ural Mountains at the western limit of Siberia all the way across Russia and northern China to northern Japan.

In addition there is an isolated breeding population in central China. The species' wintering areas are situated in South-East Asia.

Very occasionally a Siberian Rubythroat that has lost its way during migration has been found as a vagrant in either Western Europe or north-west Alaska, where birdwatchers are prepared to travel huge distances to even catch a glimpse of this beautiful bird.

■ The beautiful, musical, warbling song of the male Siberian Rubythroat.

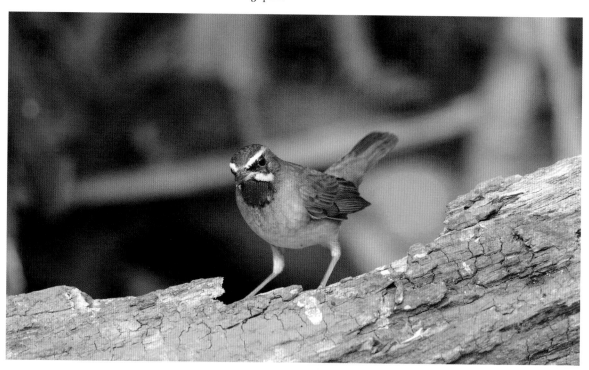

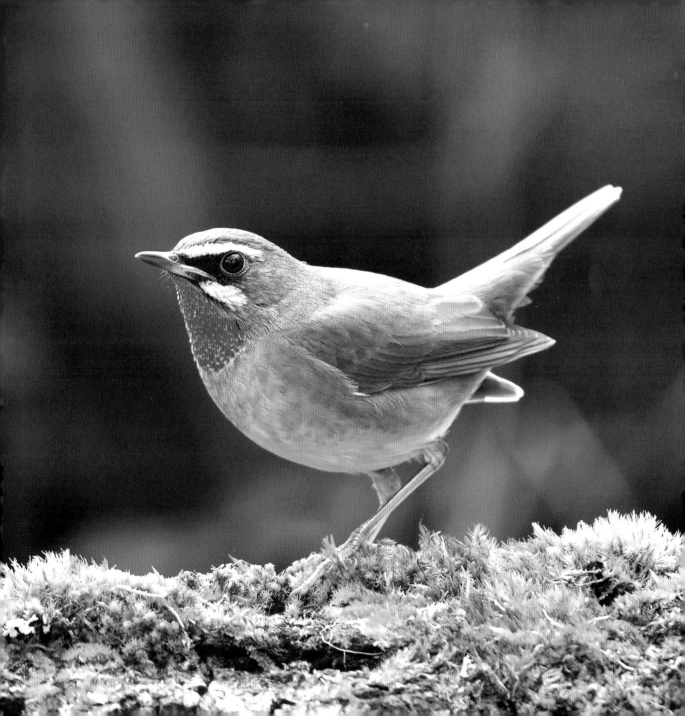

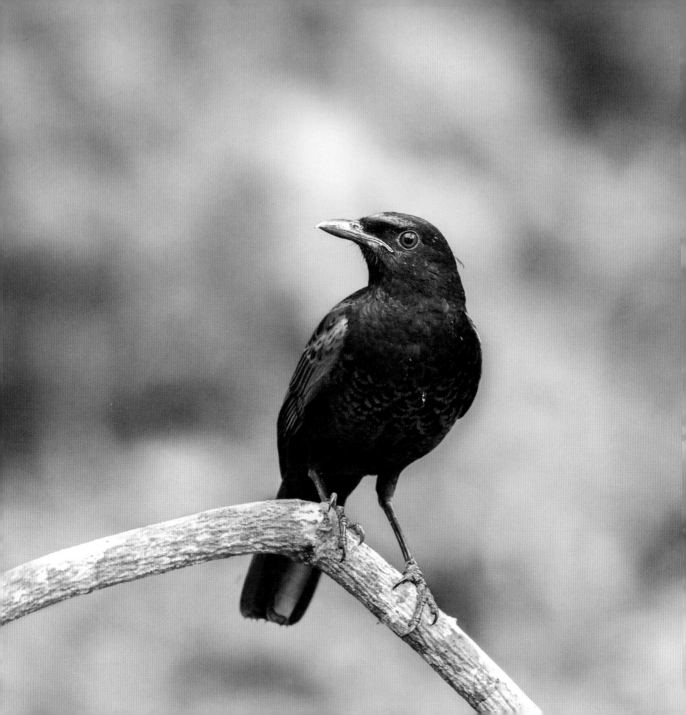

Malabar Whistling-Thrush
Myophonus horsfieldii

This is a widespread and fairly common species in the hills of Peninsular India, where it favours thick vegetation and rocky areas along streams and rivers. It is a shy, skulking bird that spends most of its time hiding inside shady vegetation or among rocks, so getting a decent view of it can be difficult. With some patient waiting one should, however, be able to see it, and it is well worth making the effort to get a sighting of this gorgeous deep blue songster, which has iridescent blue patches on its forehead and shoulder. The best way to locate this beautiful bird is to listen for its extraordinary song.

■ The song, which comprises an unpredictable long series of rich whistles that moves aimlessly up and down the scale and has an eerily human quality. Another distinct sound produced by this bird is the sharp, high-pitched *sreee* call.

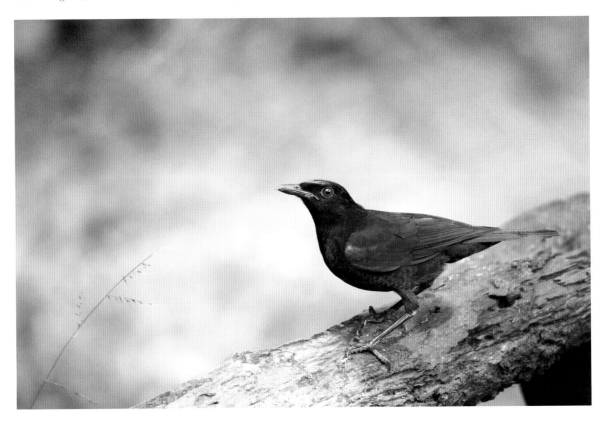

| **Common Chaffinch**
Fringilla coelebs

A widely distributed and common species with a natural range that extends from Europe all the way east to western Siberia. An introduced population is established in New Zealand. The Common Chaffinch is well known for its cheerful song, which forms the backbone of the dawn chorus in spring and early summer in a wide variety of forests and parks throughout its vast breeding range, where it is probably one of the best-known bird songs.

The song doesn't vary a lot, which makes it easy to recognise, and even the offspring of the birds that were introduced to New Zealand a long time ago still sound like European chaffinches. Outside the breeding season, when the birds cease to sing, the *tvink* and *djup* calls are commonly heard. During the breeding season the repertoire increases to include an additional six calls.

■ The cascading song and *tvink* and *djup* calls.

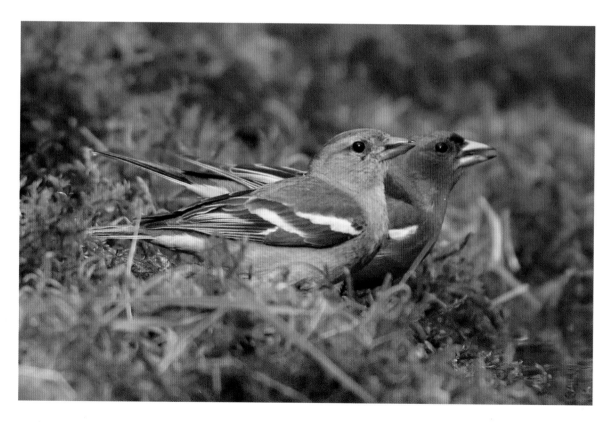

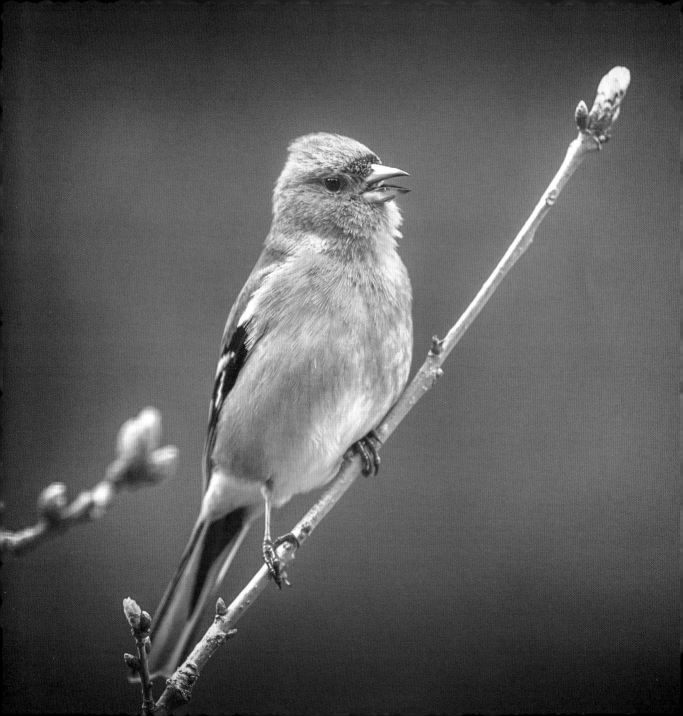

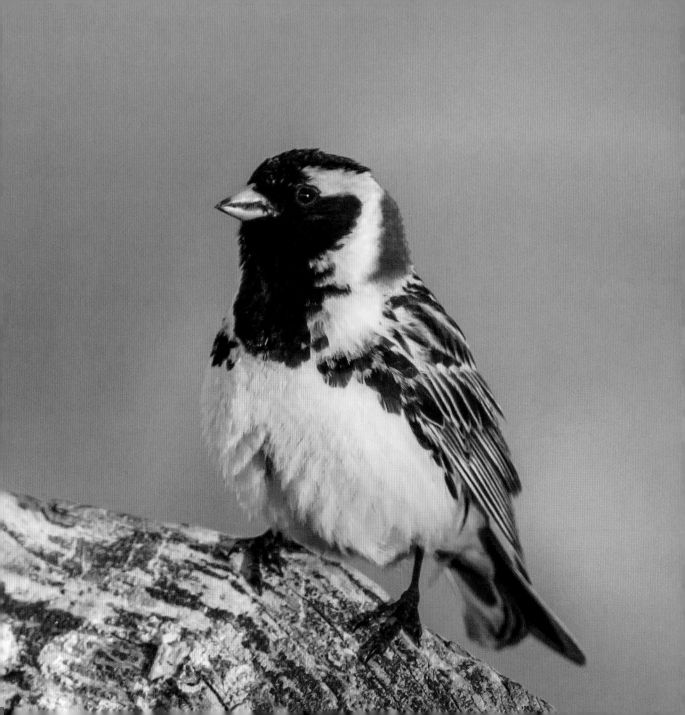

Lapland Bunting
Calcarius lapponicus

This species, which is also known as the Lapland Longspur, has a huge circumpolar distribution extending from north-west Europe across northern Siberia to northern parts of the Nearctic region. It is a common breeding bird in suitable tundra habitat, which includes areas with plenty of open space but also some cover created by small trees and bushes.

In breeding plumage the male is a very attractive little bird with its bright yellow bill with a black tip, black face and bib framed by a white band, and rufous nape-patch, while the female is like a more subtle version of the male. In addition to its bright plumage, the male has a delicate warbling song that fits perfectly into its harsh open tundra environment. The song is normally delivered from the top of a bush or when perched on a mound, but from time to time the male will perform a song flight with fanned tail.

■ The male's beautiful, fragile, warbling song.

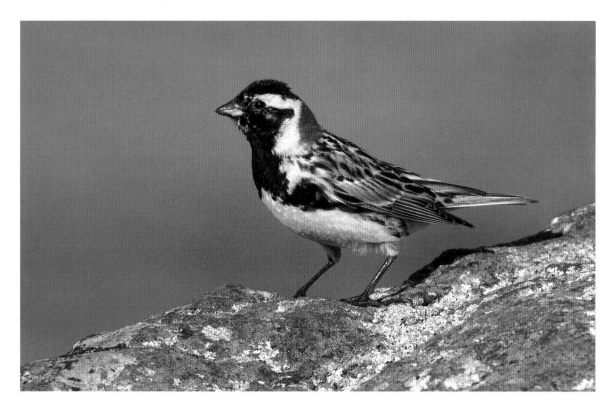

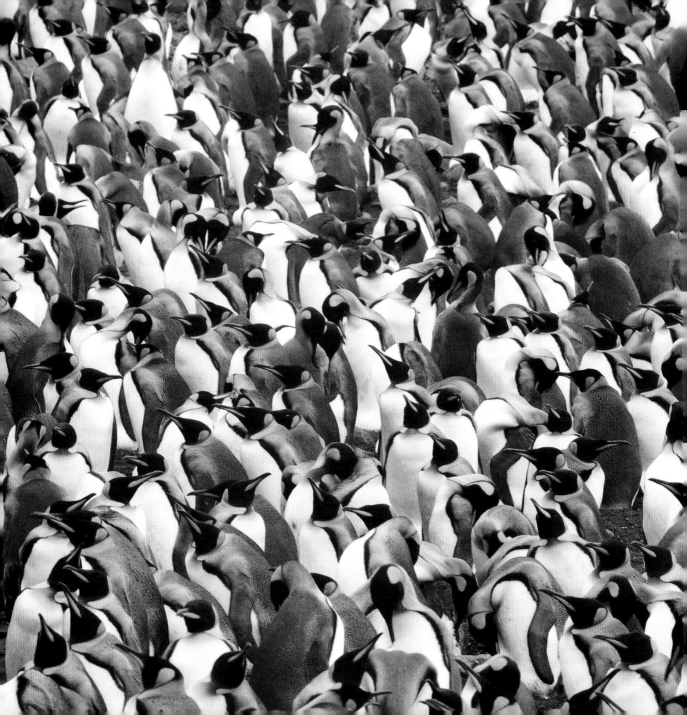

SOUND AND IMAGE CREDITS

All bird sound recordings by Hannu Jännes except the following:

Marc Dragiewicz (Horned Screamer).

Cedric Mroczko (Cory's Shearwater).

Faansie Peacock (Hadada Ibis, second part of recording).

Peter Boesman (Rufescent Tiger-Heron; Common Potoo).

Eloisa Matheu (African Fish-Eagle).

Rolf A de By (Black-bellied Bustard).

Matthias Feuersenger (Chiming Wedgebill).

Fernand Deroussen (European Turtle-Dove; Pied Butcherbird; Common Nightingale).

Marc Anderson (Tawny Frogmouth; Superb Lyrebird; Spotted Bowerbird).

Andrew Spencer (Screaming Piha, Northern Mockingbird; Brown Thrasher; Townsend's Solitaire; White-browed Robin-Chat).

Fabrice Schmitt (Capuchinbird).

Tero Linjama (Greater Hoopoe-Lark).

Paul Holt (Puff-throated Babbler; Malabar Whistling-Thrush).

Jonathon Jongsma (Wood Thrush).

Image credits as follows:

Dreamstime.com (individual photographer name in brackets): pages 10 (Awcnz62); 11 (Ruudzwanenburg); 12 left, 14, 19, 60, 70, 84 (Mike Lane); 21, 33, 94 (Andreanita); 22 (Christian Schmalhofer); 27 (Roman Murushkin); 30 (W Kruck); 36 (Sergei Zlatkov); 40 left, 65 (Stillwords); 46, 86 (Cowboy54); 50 (John Carnemolla); 62, 82 (Vasiliy Vishnevskiy); 63 (Kajornyot); 71 (Mircea Costina); 73 (Sander Meertins); 76 (Iakov Filimonov); 77 (Alex Grichenko); 80 (Vitaly Ilyasov); 81 (Menno67); 93 (Rinus Baak).

Juha Honkala: page 48.

Rofikul Islam: page 66.

Hannu Jännes: page 41 right.

Sathyan Meppayur: page 37.

Pete Morris: page 59.

Shutterstock.com (individual photographer name in brackets): front cover (Soro Epotok) and pages: 1 (Neal Cooper); 2–3 (Mital Patel); 6 (Bearacreative); 7 (Biolifepics); 9 (Ondrej Chvatal); 12–13 (BMJ); 15 (Yongyut Kumsri); 16 (Peter Vrabel); 17 (Glass and Nature); 18 (Michal Pesata); 20, 23, 43, 47 (Ondrej Prosicky); 24 (Andrew M Allport); 25, 61, 90 (Wildlife World); 26 (Michael Wick); 28 (Braam Collins); 29 (Piotr Krzeslak); 31 (Menno Schaefer); 32 (Dennis Jacobsen); 34 (SGM); 35 (Hans Wagemaker); 38 (LovelyBird); 39 (Prakash Chandra); 40 right (Florian Andronache); 41 left (Meet Poddar); 42 (Steven James Chivers); 44 (Blue Jacaranda); 45 (Kajornyot Wildlife Photography); 49 (Stockfoto); 51 (Chris Ison); 52 (Monwilai Seriputra); 53 (Chris Watson); 54 (Thanit Weerawan); 55 (Maurizio de Mattei); 56 (Clayton Burne); 57 (Rob Christiaans); 58 (Drakuliren); 64 (High Mountain); 67 (Gallinago Media); 68 (Cliff Collings); 69, 93 (Tim Zurowski); 72 (Paul Reeves Photography); 74 (Shaftinaction); 75 (Assoonas); 78 (Christian Gusa); 79 (Dave Montreuil); 83 (Viktor Tyakht); 85 (Erni); 87 (Butterfly Hunter); 88, 89 (Manu M Nair); 91 (Rudmer Zwerver).

INDEX